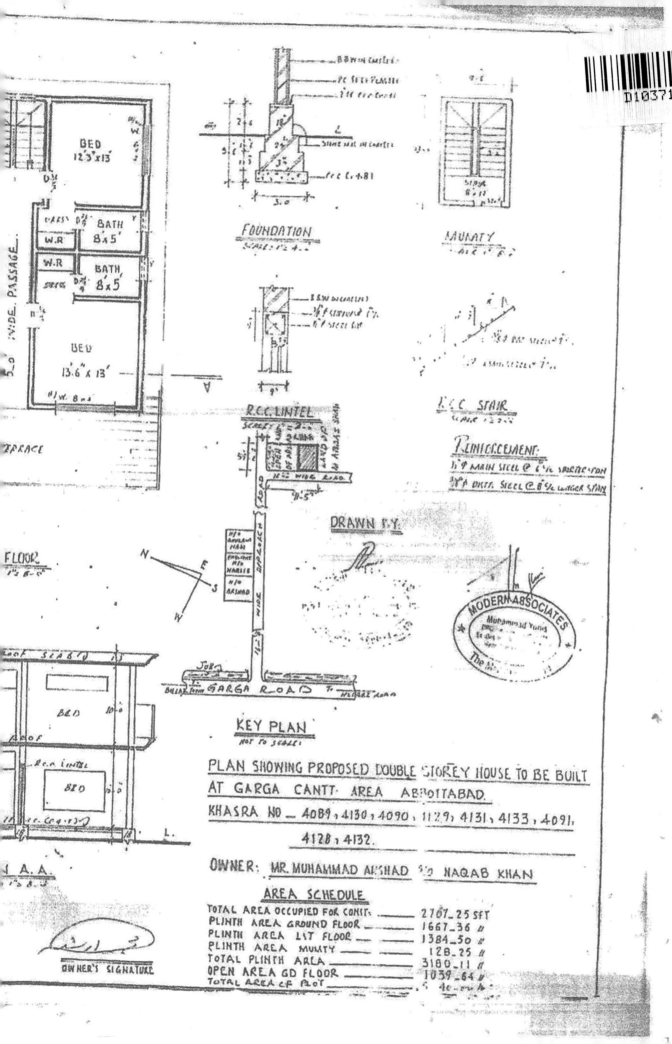

PLAN SHOWING PROPOSED DOUBLE STOREY HOUSE TO BE BUILT AT GARGA CANTT AREA ABBOTTABAD.

LIFE
BROUGHT TO
JUSTICE

(LB)

LITTLE, BROWN AND COMPANY
NEW YORK BOSTON LONDON

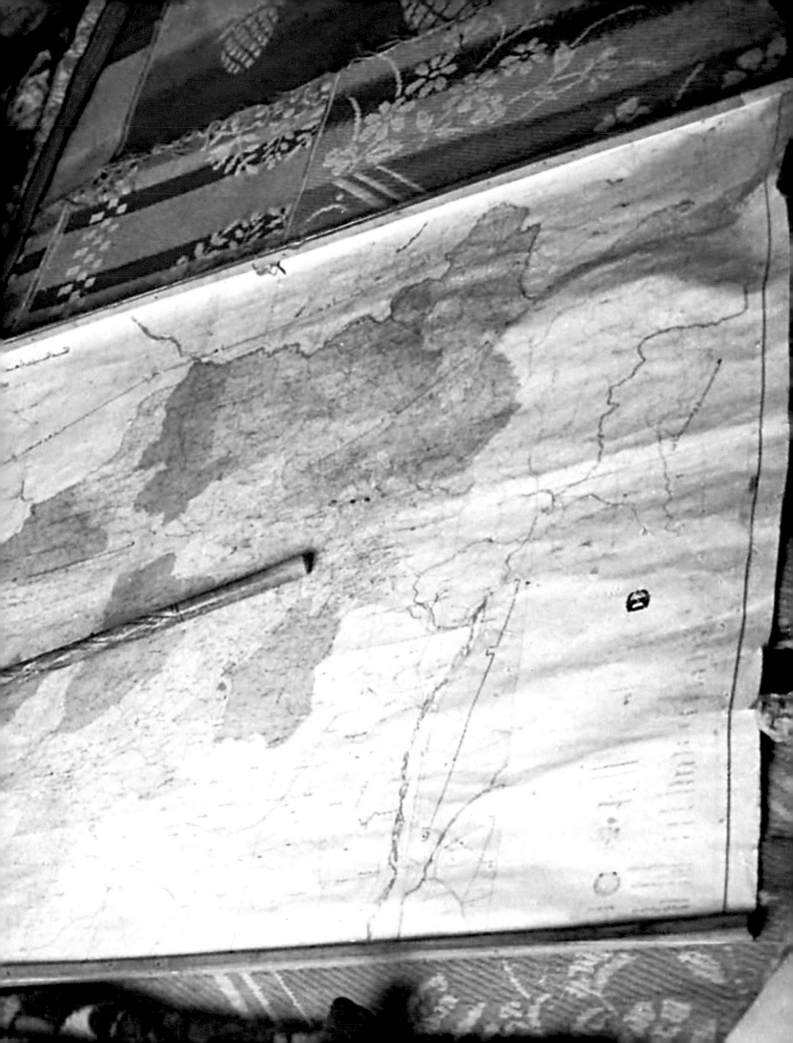

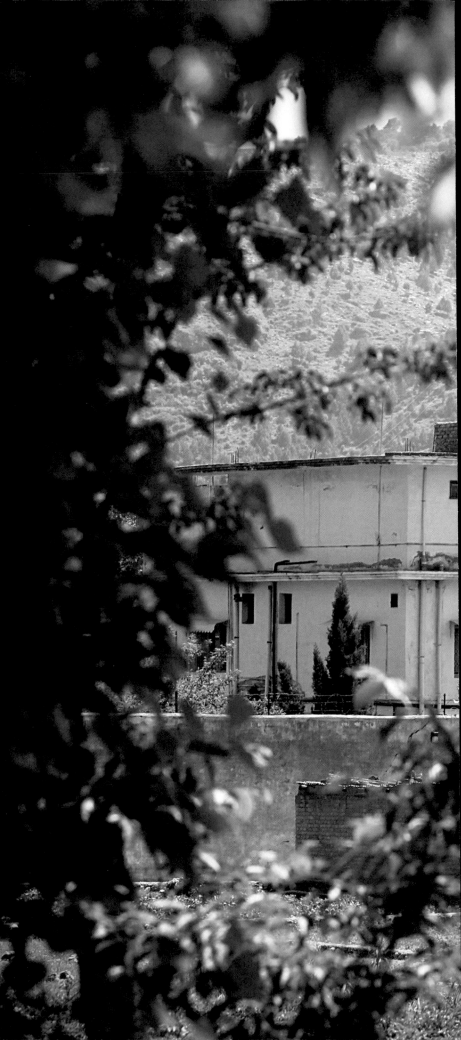

LIFE Books
Managing Editor Robert Sullivan
Director of Photography Barbara Baker Burrows
Creative Director Mimi Park
Deputy Picture Editor Christina Lieberman
Copy Editors Parlan McGaw (Chief), Barbara Gogan
Writer-Reporter Marilyn Fu
Consulting Picture Editors Mimi Murphy (Rome),
Tala Skari (Paris)

President John Q. Griffin
Business Manager Roger Adler

PUBLISHED BY HACHETTE BOOK GROUP, INC.

Chairman, Hachette Book Group USA
David Young
Publisher, Little, Brown and Company
Michael Pietsch

TIME HOME ENTERTAINMENT
Publisher Richard Fraiman
General Manager Steven Sandonato
Executive Director, Marketing Services
Carol Pittard
Executive Director, Retail & Special Sales
Tom Mifsud
Executive Director, New Product Development
Peter Harper
Director Bookazine Development & Marketing
Laura Adam
Publishing Director Joy Butts
Assistant General Counsel Helen Wan
Book Production Manager Suzanne Janso
Design & Prepress Manager Anne-Michelle Gallero
Brand Manager Roshni Patel

Editorial Operations Richard K. Prue (Director),
Brian Fellows (Manager), Keith Aurelio,
Charlotte Coco, Tracey Eure, Kevin Hart,
Mert Kerimoglu, Rosalie Khan, Patricia Koh,
Marco Lau, Brian Mai, Po Fung Ng, Rudi Papiri,
Robert Pizaro, Barry Pribula, Clara Renauro,
Katy Saunders, Hia Tan, Vaune Trachtman

Special thanks to Christine Austin, Jeremy Biloon,
Glenn Buonocore, Jim Childs, Susan Chodakiewicz,
Rose Cirrincione, Jacqueline Fitzgerald,
Carrie Frazier Hertan, Christine Font, Lauren Hall,
Malena Jones, Mona Li, Robert Marasco,
Kimberly Marshall, Amy Migliaccio, Nina Mistry,
Dave Rozzelle, Ilene Schreider, Adriana Tierno,
Alex Voznesenskiy, Jonathan White, Vanessa Wu

Little, Brown and Company
Hachette Book Group
237 Park Avenue, New York, NY 10017

www.hachettebookgroup.com

First Edition: June 2011

Little, Brown and Company is a division of Hachette
Book Group, Inc. The Little, Brown name and logo are
trademarks of Hachette Book Group, Inc.

The publisher is not responsible for websites (or their
content) that are not owned by the publisher.

ISBN 978-0-316-20173-5
Library of Congress Control Number: 2011929376

10 9 8 7 6 5 4 3 2 1

Printed in the United States of America

Page 1: Osama bin Laden in an undated portrait

Pages 2–3: Osama bin Laden in Jalalabad,
Afghanistan, in 1997, indicating where U.S. troops
are located in the Middle East—one of his principal
grievances **AP**

These Pages: The Abbottabad, Pakistan, compound
in which bin Laden was killed on May 2, 2011
Akhtar Soomro/Reuters

CONTENTS

Introduction

Every culture, society or nation has its heroes and villains, and in classifying them there are always gradations. For us, there is the upper echelon of such leaders as Washington, Jefferson and Lincoln. Then there are the Roosevelts, perhaps, and so forth down the ranks. In this same American consciousness, there resides, on the nether side of the coin, Hitler. Some might nominate Stalin or Saddam, but they weren't really our demons as much as they were their own countrymen's. So Hitler and then . . .

Who?

Hitler and . . . bin Laden.

Somehow, that sounds right. They came at us. They killed Americans. They wanted to take down our democracy.

If one views Osama bin Laden and his actions as the preceptors of the War on Terror—and many of us do—then he was culpable, as Hitler was, for a great deal of innocent death. He

wrapped himself in a religious cloak, but historians and theologians rightly point out the speciousness of his philosophy: As a Muslim, he was a blasphemer. He was, like Hitler, one of those people to whom the term *evil* was readily applied by agnostics. He merited the red X that *Time* magazine reserves for the worst among us, once these villains have been "taken out."

Bin Laden was taken out by an elite team of Navy Seals at his million-dollar compound in Pakistan on May 2, 2011—nine years and eight months after committing the crime against humanity for which he will always be remembered. He attacked the United States with a band of hijackers who had been persuaded that their deaths were for a righteous cause. Then he fled, escaping U.S. forces in the mountains of Afghanistan and finding safe harbor, for several years, in a city called Abbottabad. Which was where he was found and slain.

The news that bin Laden had been caught—had been killed—was in no way as stunning as the events of 9/11, but it was stunning nonetheless. He had become, as a fugitive, a true bogeyman, an almost mythical being. When the evil runs that deep, as with Hitler and Stalin, the person ceases to exist, his humanity is forgotten. Perhaps a better way of thinking of it: Humanity is overrun. And for the culture, society or nation that is asked to consider this, the subject becomes a symbol. Osama bin Laden has, for a decade, meant something to every American—but he has rarely been seen as an individual human being.

In these pages is that person.

LIFE, founded 75 years ago, has always taken as its mission: to bear witness. We were on the beach on D-Day with Robert Capa, in the hills of Korea with David Douglas Duncan, in the mire of Vietnam with Larry Burrows. We looked closely at Hitler—and Mussolini and Stalin and Pol Pot and Saddam and so many others. We chronicled bin Laden's massive crime on 9/11.

And now we look at the life and, finally, the death of the man himself.

At 9:02 a.m. Eastern Time on September 11, 2001, United Flight 175 with its 65 passengers and crew blasts into floors 78 to 87 of the World Trade Center's South Tower in a tumultuous explosion, the second of the morning, and people all across the globe suddenly realize this is no accident.

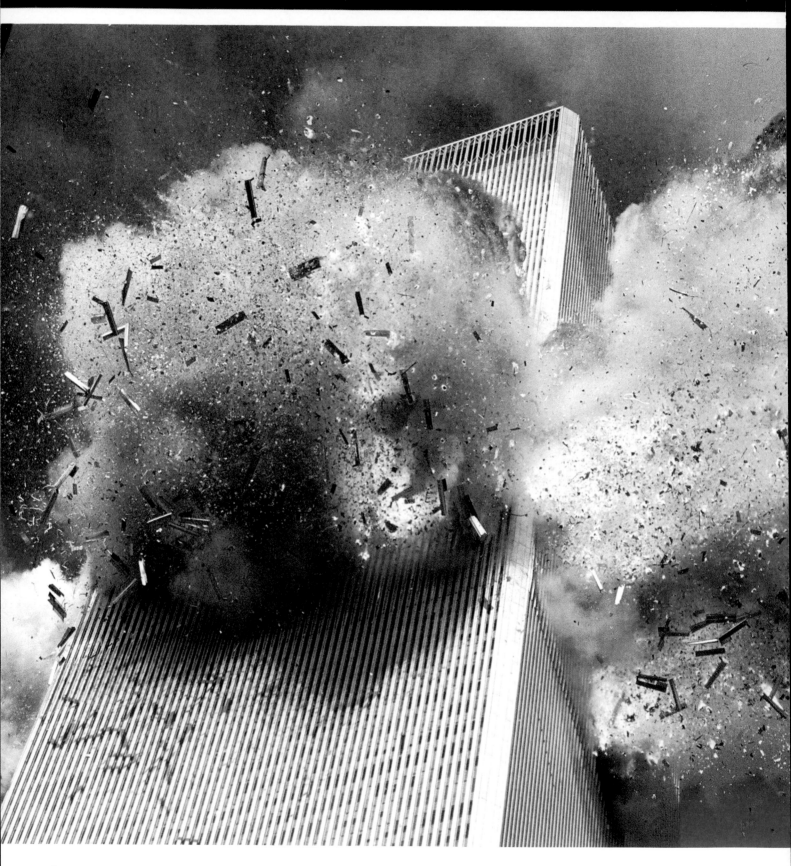

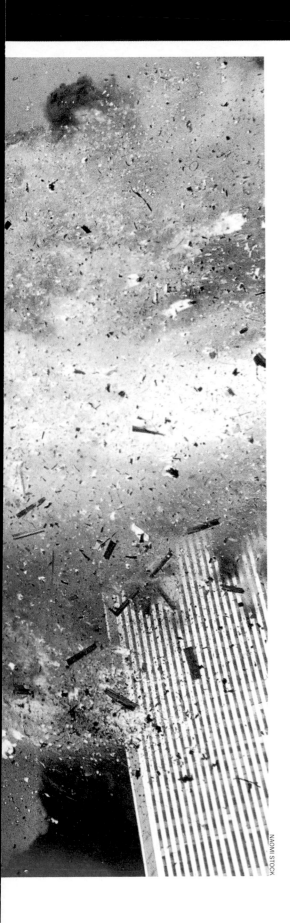

Even if the country was unprepared, the country's leaders were—and had been—girding for the worst. They knew a lot about Osama bin Laden, who had already been declared by the Clinton administration a primary enemy, and they gleaned that his loose confederation of terrorists known as al-Qaeda was planning a major assault. Where and when were the crucial questions.

The citizenry hadn't allowed this to register, even though *bin Laden* and *al-Qaeda*—an exotic name, an exotic term—had been buzzing in the public discourse. Merely buzzing.

To emphasize: The morning of September 11 was nothing like the dawn of December 7, 1941, when the nation was already tearing itself apart over the question of isolationism, as the Nazi march through Europe and Japanese expansionism had the entire world—America included—wondering what was next, preparing for what was next. This was a September day in a nothing-happening year in a country that hadn't been attacked on its own ground in more than a half century, and hadn't seen blood spilled in wartime on its continental soil since its own civil conflict 136 years earlier. Yes, this was, perhaps, a complacent country. But it was a country with such a long history of peace within its borders that it was all but impossible to be at the ready.

Signs were missed, no question. Terrorists of a like mind-set to those who went into action on September 11—terrorists either directed by or more likely inspired by this character bin Laden—had already taken a shot at the World Trade Center in New York City. The 1993 attack, in which bombs were detonated in a parking garage, killed six and led to life terms for Ramzi Yousef and five other Islamic extremists (and who among us paid attention to bin Laden's public lionization of Yousef?) . . . American embassies had been bombed in Africa . . . Another radical Islamist had been caught after crossing the Canadian border just prior to the great millennium celebrations. It was learned that this last man was intent on bombing Los Angeles International Airport. In the year 2000, an American destroyer,

the USS *Cole*, had been bombed while refueling in Yemen.

All that news, and yet it eventuated that there were terrorists walking among us in the weeks and months prior to 9/11—terrorists who were taking flying lessons, while not seeming keen to learn very much about takeoff or landing. Yes, signs were missed.

Even if they hadn't been, there is no certainty that the terrorists would have been foiled, for what they—what *he*—did was, at bottom, to exploit American freedoms. In the land of the free, where individuals can come and go, where rights of movement and privacy are protected, they—*he*—took advantage. They crossed borders and entered a nation that holds paramount freedom of speech, assembly and religion (in a horrible irony, a nation that since its inception has defended an individual's right to worship as he will). Then they attacked from within.

They did so on a day that, were it not destined to be remembered as one of the most dreadful in America's history, might have been recalled, on the East Coast at least, as another perfect day in a glorious month. They did so on September 11, beginning before dawn. At 5:45 a.m., Mohamed Atta and Abdulaziz Alomari passed through security in Portland, Maine, and boarded a commuter flight to Boston. Also heading for Logan International Airport were their confederates Waleed M. Alshehri, Satam al Suqami and Wail Alshehri. Those five would board American Flight 11 bound for Los Angeles. Five others were also at Logan that morning. Their flight, United 175, also destined for L.A., took off 14 minutes after the American jet, and by 8:15 a.m., 127 other passengers, 20 crew members and 10 hijackers were aloft, headed for their destiny.

What transpired was so stunning in its implications that the world would be turned upside down. In a way as pronounced and forceful as was December 7, 1941, the original "date which will live in infamy," this would bring about an abrupt reversal, a complete realignment of attitudes, beliefs and expectations. We have never been the same, and that remains true despite the events of May 2, 2011.

By day's end on 9/11, the name Osama bin Laden had been pinned to the attack. The manhunt was on.

And most Americans asked: Who *is* this guy?

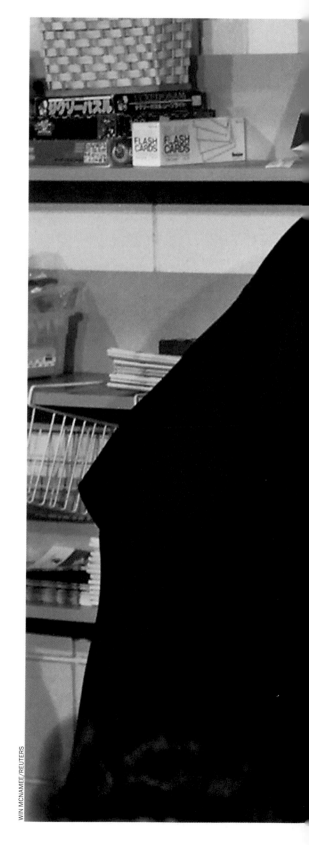

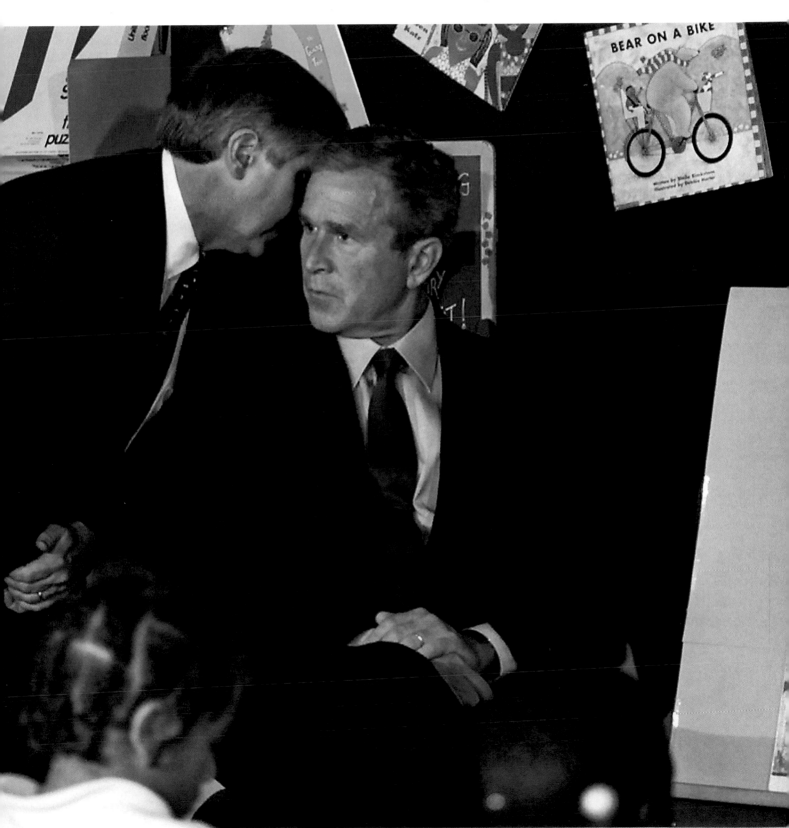

Three minutes after the second tower is hit in New York City, White House Chief of Staff Andrew Card whispers to President Bush, who is meeting with children at the Emma E. Booker elementary school in Sarasota, Florida, that America is under attack.

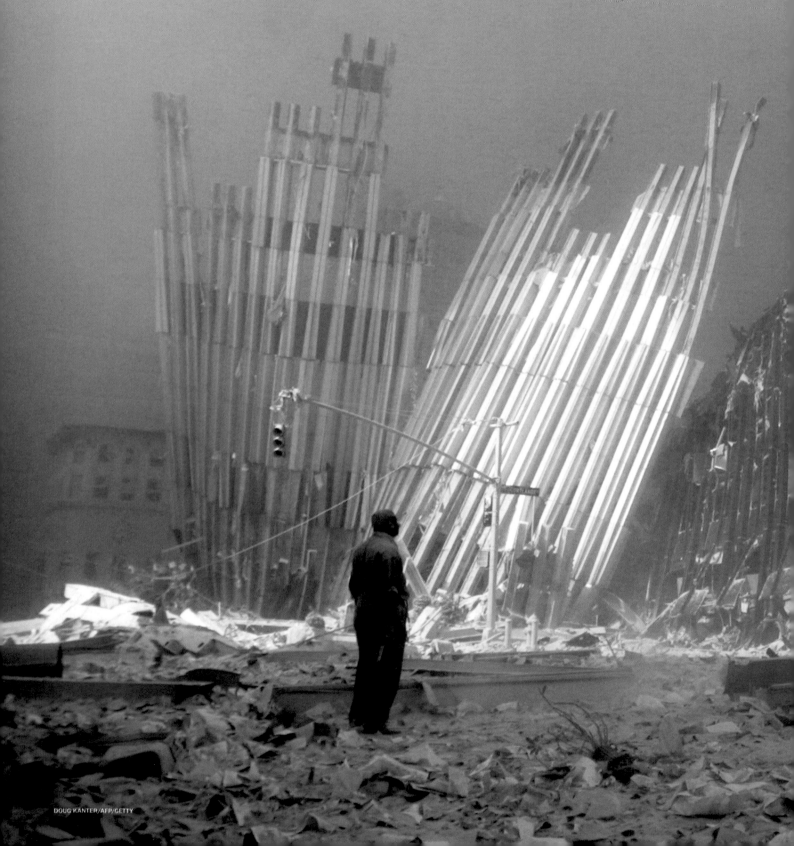

"If anyone can hear me, make some noise and we'll come help you." Having called out his plea, this man at the corner of Church and Cortlandt Streets in Manhattan, fire extinguisher in hand, awaits a response. Like so many, he wants only to somehow reach out, somehow contribute, somehow assist. He is confused, perhaps bereft, and can only shout in response to the horror of what has happened. By this point on 9/11, everyone knows at least one thing: This is a terrorist act, most probably launched by foreigners. Some in the intelligence community immediately suspect that Osama bin Laden and his al-Qaeda outfit are behind the attacks, and by nightfall his name is in the newscasts. On this day, the coordinated suicide bombings involving four jetliners will claim nearly 3,000 victims and the 19 hijackers. In New York City, 2,752 are killed, 341

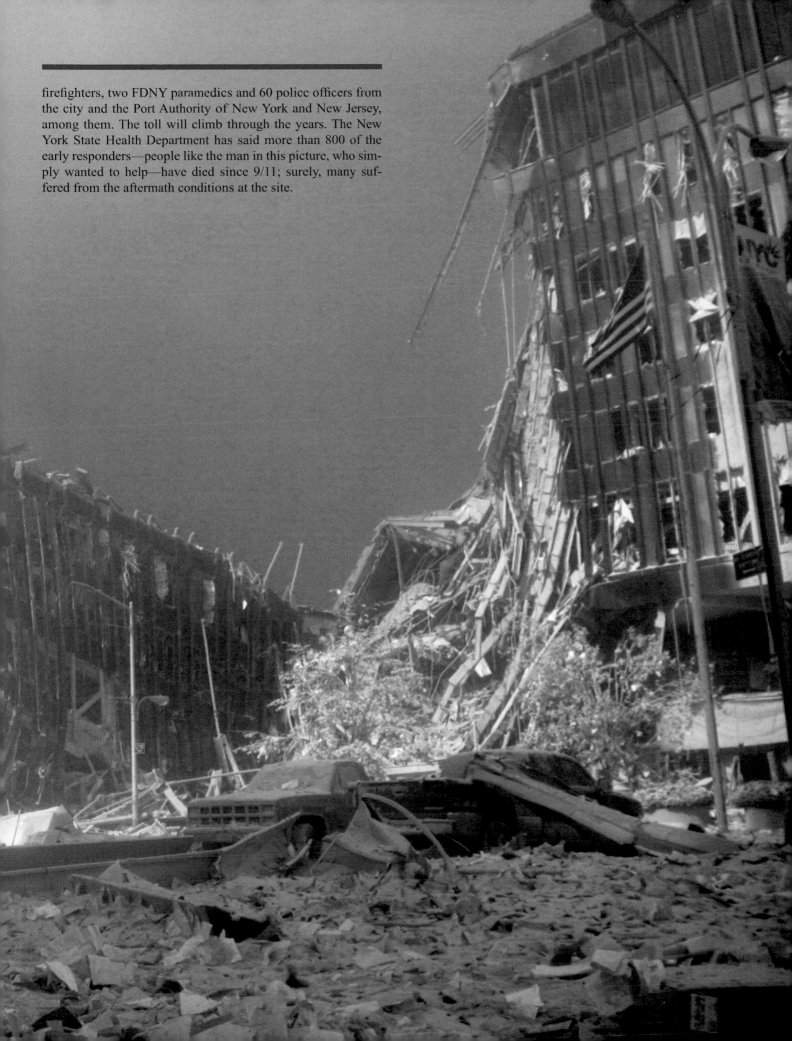

firefighters, two FDNY paramedics and 60 police officers from the city and the Port Authority of New York and New Jersey, among them. The toll will climb through the years. The New York State Health Department has said more than 800 of the early responders—people like the man in this picture, who simply wanted to help—have died since 9/11; surely, many suffered from the aftermath conditions at the site.

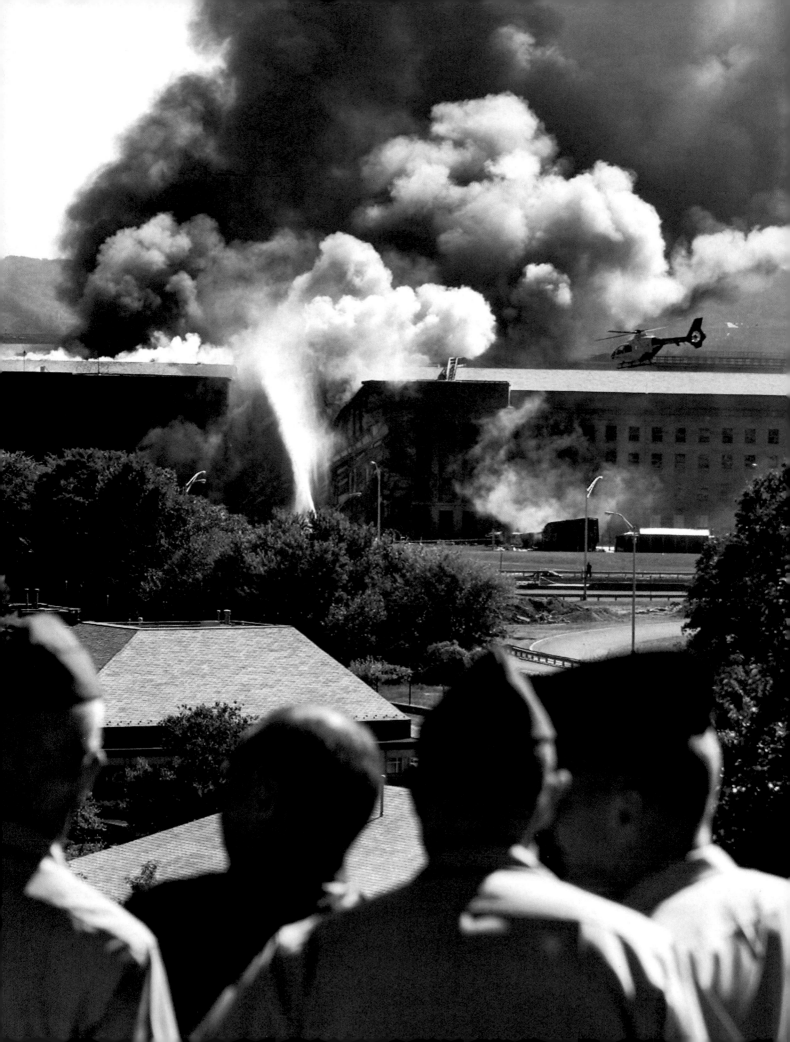

While two jets target the Twin Towers, another pair are headed for Washington, D.C.; one gets there and slams into the Pentagon (opposite) in Arlington, Virginia, while the other crashes into an open field near Shanksville, Pennsylvania (above), 80 miles southeast of Pittsburgh, after passengers on the plane bravely battle the hijackers for control. One hundred and eighty-four people are killed in the attack on the Pentagon, and all 45 aboard United Airlines Flight 93—which was probably targeting either the White House or the U.S. Capitol—perish in Pennsylvania. The thing that so horrifies Americans is that all the nearly 3,000 dead are innocents. These were not armed combatants, these were civilians, and also: Reflective of our melting-pot nation, they were from everywhere. People from more than 70 countries died on 9/11. In some places in the Middle East, however, the attacks are seen as legitimate extensions of jihad, and there is rejoicing. Certainly in the headquarters of al-Qaeda, there is jubilation.

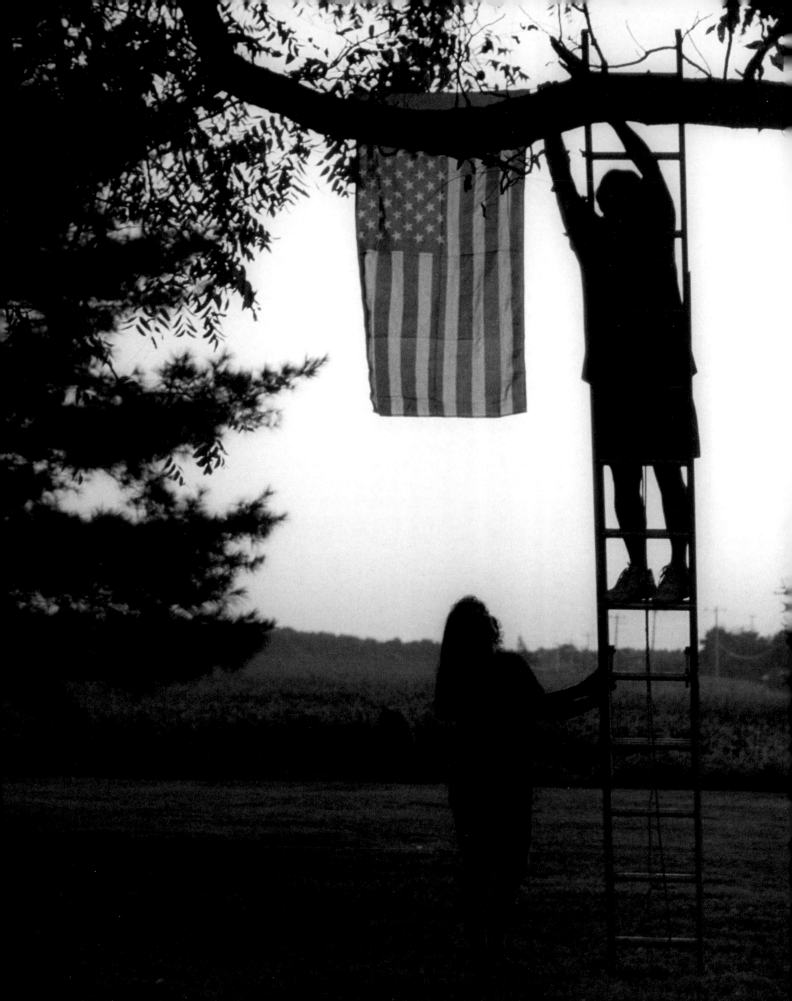

The surge of patriotism in the United States in the wake of 9/11 is as overwhelming as it is pained. Flags bloom coast to coast; here, George and Darlene Wolski hang theirs in Dover, Delaware. The colors of autumn in America, 2001, are not burnished browns and golds but vibrant reds, white and blues. The country, while grief stricken, is united, resolved, determined. And furious. The drumbeat continues for 26 days after 9/11, then comes the explosion as Operation Enduring Freedom is launched. American forces head for Afghanistan, their ultimate target a man named Osama bin Laden. Many of our soldiers—and citizens—still have only the vaguest notion of who he is or what he might stand for. But they are learning fast.

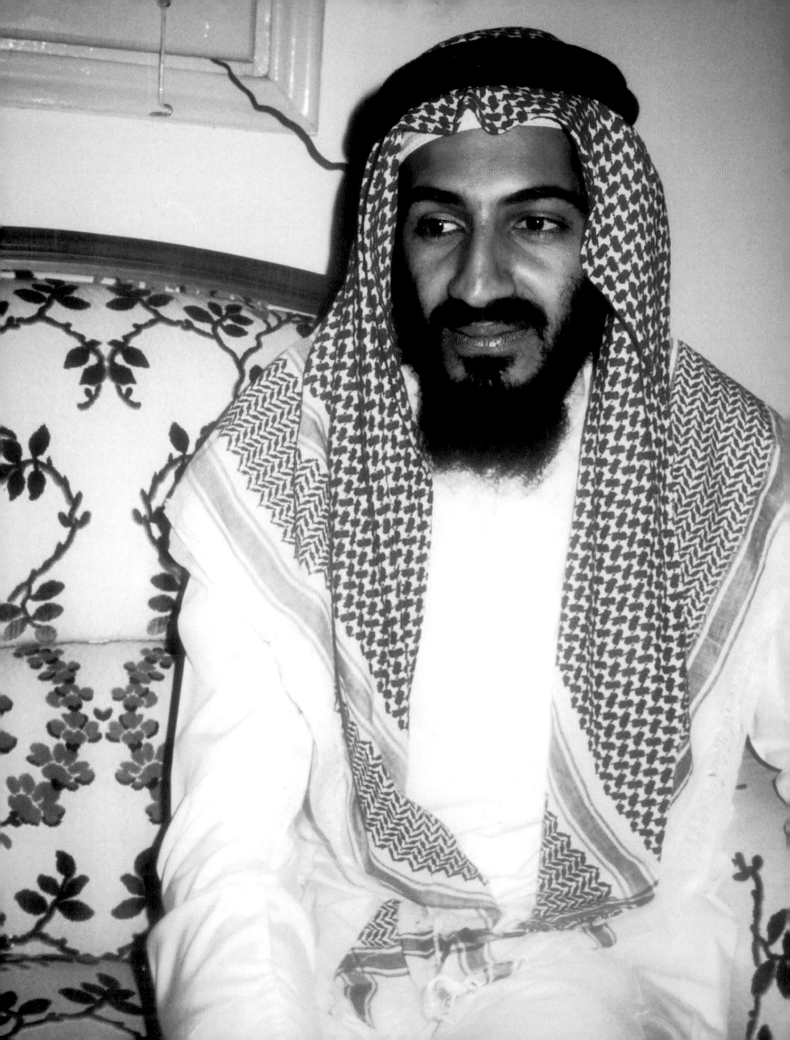

Scion & "Soldier"

AND NOW WE BEGIN TO ADDRESS THE ULTIMATE QUESTION OF our terrible prologue chapter: Who *is* this guy?

Who was this man behind 9/11? What were the whys and wherefores? If Americans scrambled frantically to understand him at the time, it is only with the passage of years that Osama bin Laden's strange, twisted narrative has become clear.

It is sometimes said that a child is "born to privilege," with the standard meaning being: to economic and social advantage. This was certainly true, on paper, in the case of Osama bin Laden. But, certainly from a Westerner's vantage (and just as surely for bin Laden himself), the story is and was much more complicated. There was money aplenty, but issues of religion, disassociation and domestic strife were also in the mix. There was also, with bin Laden personally, an ever-growing sense of self-righteousness and an off-the-charts narcissism: He came to see himself as nothing less than a latter-day Muhammad. He was born to privilege, yes, but that would only prove fuel for the fire, giving him the financial wherewithal to do what he wanted, when he wanted, to whomever he wanted.

Whether Osama bin Muhammad bin Awad bin Laden was born in 1957 or early 1958 (his claim) is still debated, so whether he was 53 or 54 at the time of his death is also inconclusive. But he was certainly the seventh son and 17th child of Muhammad bin Awad bin Laden, who would eventually sire 54 offspring. Osama was born and raised in Saudi Arabia. His father was a native of Yemen and his mother, Muhammad's fourth wife, was from Syria. They divorced a year after Osama's birth. He grew up the product of what Americans would call a broken home, in a society that made severe judgments regarding class and status. Bin Laden not only was an outsider as the son of non-Saudis, he was an outsider in his own family as his father's previous three wives had been born in Saudi Arabia, and so all his older siblings were at least half native. Muhammad bin Laden died in a plane crash when Osama was 10, and the boy, along with his plethora of brothers and sisters, inherited a billionaire's fortune that had been built in the construction industry. It has been reported that Osama's share was $80 million, and his fortune as of September 11, 2001, which formed a substantial part of al-Qaeda's financial bedrock, has been variously estimated at $200 to $300 million.

His father had been a self-made man, and earlier in life had served as a porter for pilgrims to various Islamic holy sites. The family was intensely religious. Osama, as a boy, was educated in Wahhabism, a fundamentalist Muslim strain that, among other things, preaches an intolerance of Western values. It is interesting that most of his older brothers and sisters eventually traveled the world in search of higher education or to promote the family business. They came into contact with or even adopted Western mores and values; several bin Ladens, in fact, were living in the United States when

This picture was made circa 1987, so bin Laden is about 30 years old. Having dropped out of school to join the fight in Afghanistan, he is in thrall to his former teacher, the radical Islamic studies lecturer Abdullah Azzam. Azzam will be assassinated in Pakistan in 1989— the year the Soviets withdraw from Afghanistan—but by that time, bin Laden is ready to lead on his own.

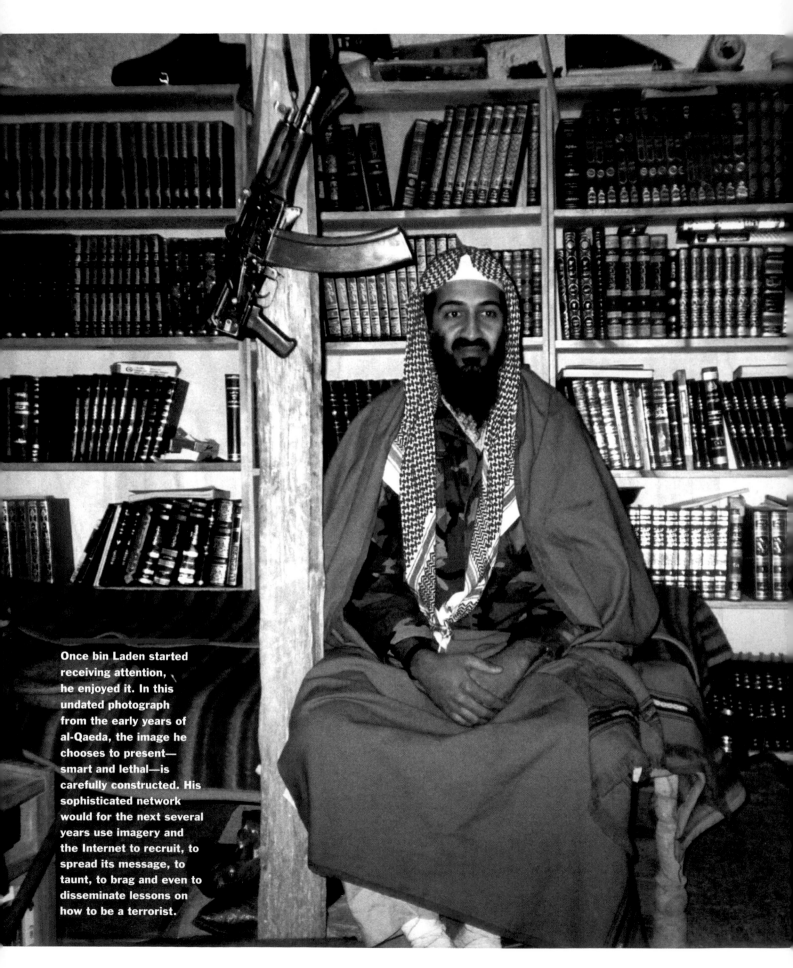

Once bin Laden started receiving attention, he enjoyed it. In this undated photograph from the early years of al-Qaeda, the image he chooses to present—smart and lethal—is carefully constructed. His sophisticated network would for the next several years use imagery and the Internet to recruit, to spread its message, to taunt, to brag and even to disseminate lessons on how to be a terrorist.

Scion & "Soldier"

the Twin Towers fell. But Osama, it can be said, never left home—if home is broadly defined here as the Arab Middle East. As he grew ever more serious about his Muslim faith, the realities of the world around him came into relief. His family kept horses and had a vast estate, and he hung out with the children of Saudi royalty. But were they like him? They certainly were not. Their life view wasn't based upon Islamic precepts but upon wealth and political power. And how could his own siblings be doing business in (and with) foreign countries like the U.S., the sanctuary—the breeding ground—of infidels?

So Osama bin Laden grew up in this huge household, in the lap of luxury, but without the comfort of allegiance to either family or state. He was cared for, coddled even, but untethered. He was a young man bound to be a seeker. To the world's great misfortune, he would find what he was looking for in a radical and obviously wrong-headed view of Islam.

He was schooled, as were several of his brothers, at Al-Thager Model School. One of his teachers there, who also tutored him in English after hours, was an Irishman named Seamus O'Brien, who later remembered his experience at Al-Thager as an attempt to educate arrogant, wealthy, not particularly bright children. He would recall Osama bin Laden as an inoffensive, in no way troublesome boy. That would begin to change in college.

By the time bin Laden matriculated at King Abdulaziz University in the Saudi city of Jedda in 1976, he had already married a 15-year-old cousin, Najwa Ghanem, the first of his eventual five wives. (He would father 24 children in his lifetime, 11 by Najwa. Many of his offspring wound up in Iran after 9/11; some were in the Abbottabad compound with bin Laden and three of his wives at the time of his death. His fifth wife, Amal Ahmed al-Sadah, was the woman shot in the leg during the assault, and an adult son—one of his 11 boys—was one of the five killed that night. It is believed the daughter at the site who would confirm her father's death for Pakistani police was Amal and Osama's daughter, Safiyah. Of interest: She had been named for a legendary Islamic warrior. "I became a father of a girl after September 11," bin Laden once told a Pakistani journalist. "I named her after Safiyah who killed a Jewish spy at the time of the Prophet. [My daughter] will kill enemies of Islam like Safiyah.")

It is said that bin Laden majored in economics and business administration in college, but it is also said that his main concentrations were poetry, investigating the true message of the Koran, Islam's sacred book, and examining the meaning and validity of the term *jihad*—holy war. He was in thrall to two Islamic scholars, Muhammad Quttub and particularly the charismatic Palestinian Sunni lecturer and theologian Abdullah Yusuf Azzam. Azzam was all about jihad, and felt it was a Muslim's duty to fight for lands once belonging to Islam, and for principles threatened by infidels: "Jihad and the rifle alone: no negotiations, no conferences and no dialogue." In his book *Join the Caravan* and in other writings and teachings, Azzam sent out a rallying cry to young

During the war against the Russians in Afghanistan, bin Laden is most important as a money man. But as he builds and burnishes his image—here in Saudi traditional dress, a white djellaba and red kaffiyeh, accented by weaponry—he becomes an inspiration to young Arab freedom fighters such as these following him.

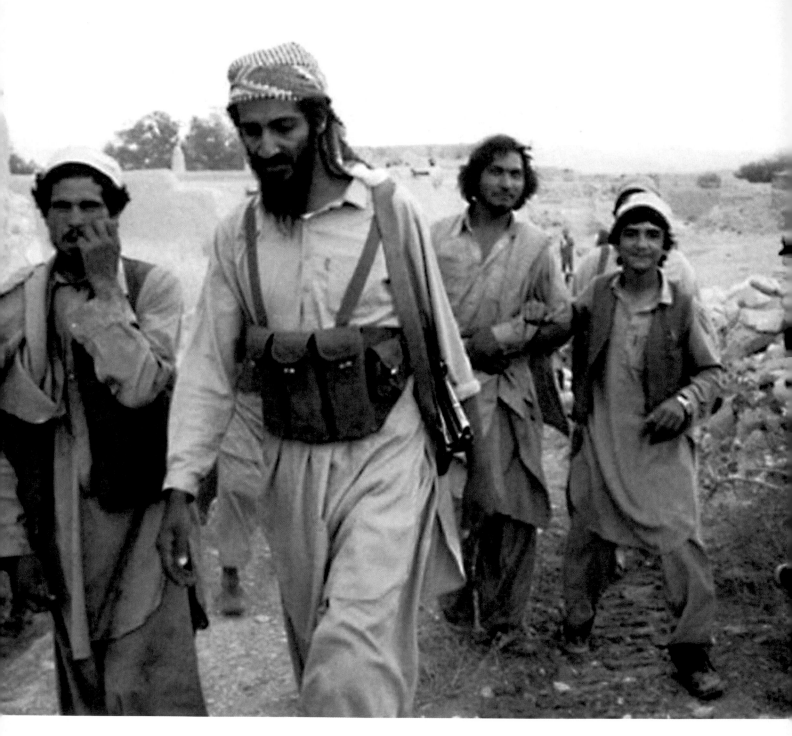

Scion & "Soldier"

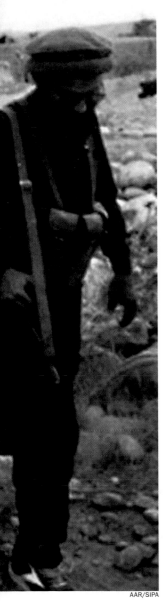

Muslims that would inspire and inform the founding of al-Qaeda.

Bin Laden was learning from and being encouraged by Azzam at King Abdulaziz University, and not coincidentally was falling in with the Muslim Brotherhood, a radical Islamic group that perceived infidels everywhere, including in the Saudi monarchy. In 1979, enemies were made plain for the young man when upheaval in the Muslim world saw an Islamic revolution topple the shah of Iran; Egypt and Israel enter into a peace accord; and the Soviet Union invade Afghanistan to quell Islamist uprisings. Azzam was already in Pakistan and quickly became involved in the Afghan Arab resistance against the Soviets, and he encouraged his former acolyte to join him. Within two weeks of the occupation, bin Laden arrived on the Pakistan-Afghanistan border and the legendary part of his life began.

The word *legendary* is purposefully chosen; "mythical" would have been a bit too strong. Bin Laden did go to Afghanistan, did serve, did use his fortune to establish training camps and feed the troops, did attract thousands of jihadists to the cause with his personal history. But how accurate was that history? As Kate Zernike and Michael T. Kaufman wrote in their *New York Times* obituary of bin Laden on May 2, 2011, "To young would-be recruits across the Arab world, bin Laden's was an attractive story: the rich young man who had become a warrior. His own descriptions of the battles he had seen, how he had lost the fear of death and slept in the face of artillery fire, were brushstrokes of an almost divine figure." Intelligence sources, as Zernike, Kaufman and others have pointed out, claim that bin Laden was actually in combat only once, and even then all but inadvertently, when a Soviet barrage of Jaji forced the Arab Afghans to hunker down in caves dug with bin Laden's construction equipment. As Milton Bearden, the always quotable, retired 30-year CIA veteran, put it on PBS's *Frontline:* "Afghanistan, the jihad, was one terrific photo op for a lot of people . . . There's a lot of fiction in there."

That photo op would benefit no one more than bin Laden, who, once the Soviet aggression had been successfully deterred by the late 1980s, was poised to become, through contacts made and because of established reputation, what Bearden would call "the North Star" of terrorism. Whether he had ever really been "a soldier" didn't matter anymore. He was the figure to whom disaffected young Arabs gravitated, bearing either their deep religious passions or their myriad discontents about the powers that be.

It has been pointed out many times that there is irony to the fact that the United States supplied billions of dollars' worth of matériel to the Arab side as it fought the Soviets, and that the military complex in Tora Bora where the fugitive bin Laden would one day hide had been built years earlier with CIA assistance as a base for bin Laden's freedom fighters. It is cruel irony indeed to take the next step: that, unwittingly, America helped nurture its very worst enemy. America helped to make the monster.

Muhammad bin Awad bin Laden (below, left), eventual father of Osama and 53 other children (by 22 wives), is seen in a portrait. The Saudi Binladin Group, which would grow into an international firm engaged in myriad activities and would eventually realize annual grosses of $5 billion, profited mightily as the firm of choice for the Saudi monarchy. Muhammad bin Laden was King Faisal's chief contractor, and his company was awarded all the plum and sensitive assignments, including major renovations in Mecca and at the Al-Aqsa Mosque in Jerusalem. Muhammad's relationship with the Saudi royals was handed down. Salem bin Laden took over the family empire upon his father's death in 1967, but he was killed in an airplane crash in San Antonio, Texas, in 1988. He was succeeded by his younger brother Bakr, who shows King Fahd how the Medina Mosque enlargement is progressing (below, right). As was true of all the brothers, Osama worked in the family business for years. In this period he "settled down," you might say, marrying and beginning a family, including (opposite, top) Fatima, Sa'ad, Omar, Mohammed, Osman and Abdul Rahman. Opposite, bottom, is Osama's former house in the Sudanese capital Khartoum. After this second Middle East country expelled him in 1996, his "normal life" was well and truly over and he was a peripatetic terrorist. How different his existence was from those of his siblings, and then the next generation of bin Ladens—and how appalled he must have grown at the courses some relatives chose—can be sensed on the following few pages.

FROM GROWING UP BIN LADEN BY JEAN SASSON

GAMMA

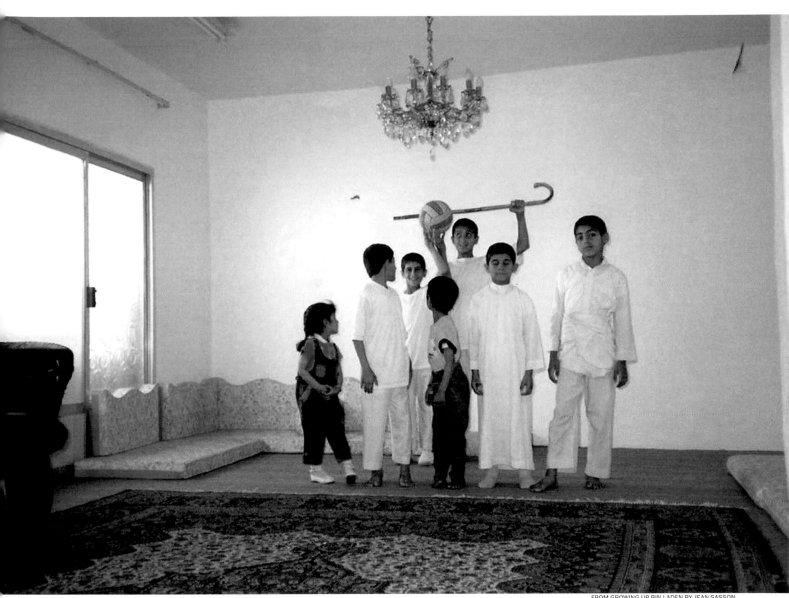

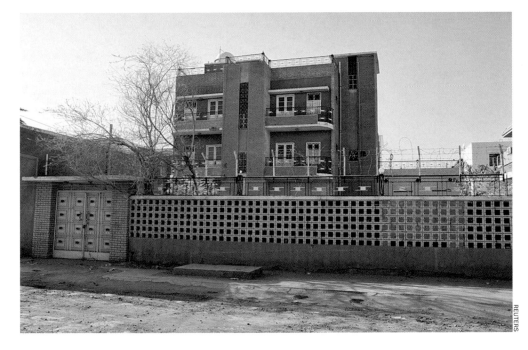

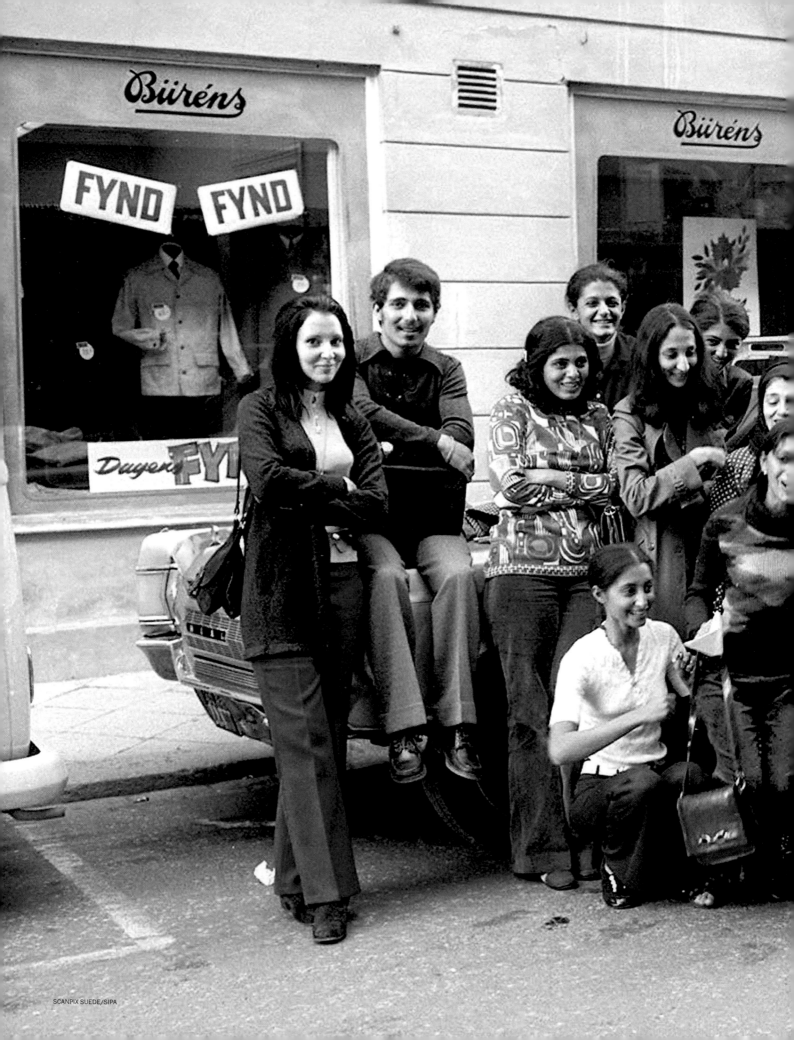

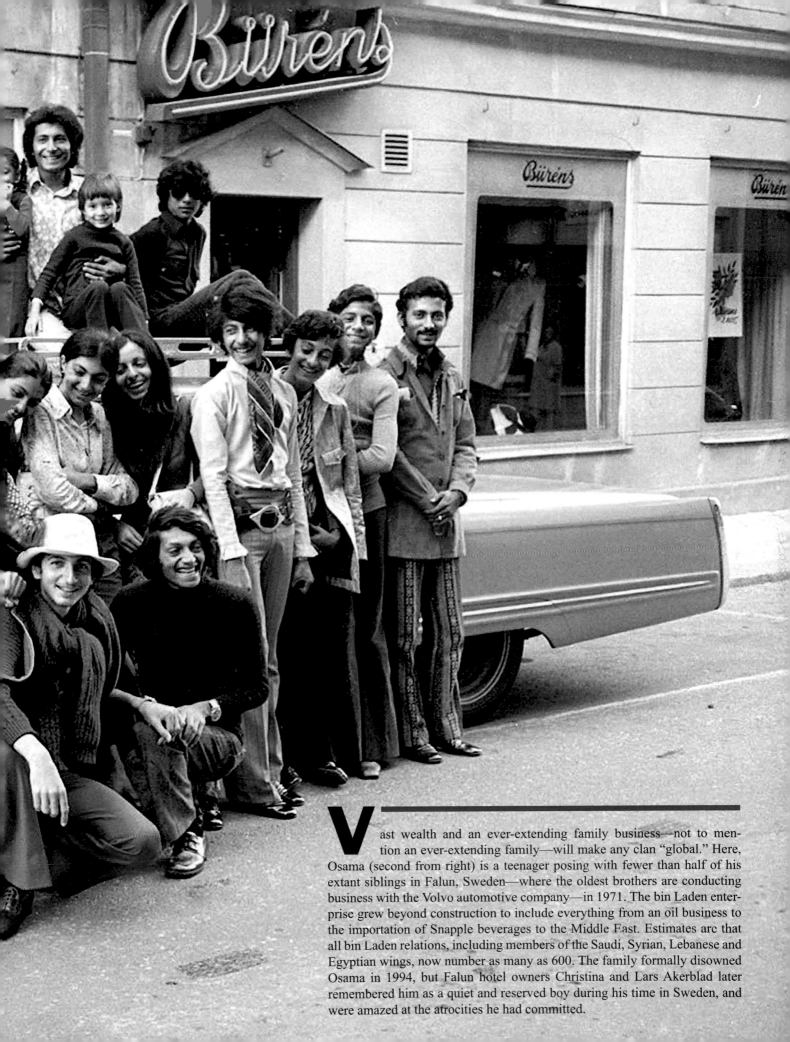

Vast wealth and an ever-extending family business—not to mention an ever-extending family—will make any clan "global." Here, Osama (second from right) is a teenager posing with fewer than half of his extant siblings in Falun, Sweden—where the oldest brothers are conducting business with the Volvo automotive company—in 1971. The bin Laden enterprise grew beyond construction to include everything from an oil business to the importation of Snapple beverages to the Middle East. Estimates are that all bin Laden relations, including members of the Saudi, Syrian, Lebanese and Egyptian wings, now number as many as 600. The family formally disowned Osama in 1994, but Falun hotel owners Christina and Lars Akerblad later remembered him as a quiet and reserved boy during his time in Sweden, and were amazed at the atrocities he had committed.

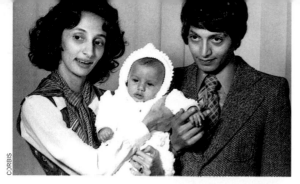

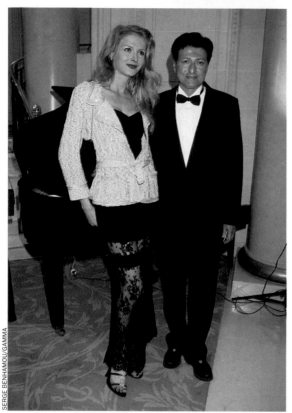

When there are 54 kids, they will go in various directions; these pictures are meant to illustrate just how wildly divergent the bin Laden siblings have been in their interests, and also how easily things might have been different. At left, top, is Salem bin Laden with his first wife, Sheikha, and their son Sara in London in 1975. Salem, CEO of the family firm after his father's death, would jet back and forth between London and Saudi Arabia, then was killed when an ultralight airplane in which he was riding got tangled in power lines in Texas. At left in 2006 is Osama's half-brother Yeslam bin Laden at an "April in Paris" party at the Four Seasons Hotel George V in the City of Light. While the family publicly disassociated itself from Osama, some authorities thought this might be a divorce of convenience and in 2002 searched Yeslam's villa in Cannes (below), reportedly looking for evidence of terrorism-related money laundering. The previous year, Yeslam's estranged wife, Carmen, had been asked by ABC News if some within the family had given money to Osama, and she answered, "My opinion is yes . . . I think they would say, Okay, this is—for Islam they would give. You know, for Islam they would give." Opposite: Yeslam and Carmen's daughter was born in Los Angeles in 1975 and today is the model and aspiring singer Wafah Dufour (her mother's maiden surname), who also holds law degrees from Geneva University and Columbia Law School and dual citizenships from the U.S. and Switzerland. She lives in London. Supposedly, her father and the other bin Ladens have not spoken to her since she was 15 years old because of her Western ways; but then, her dad has released a perfume called "Yeslam." The bin Ladens, who rationalize all this among themselves, are everywhere and do everything.

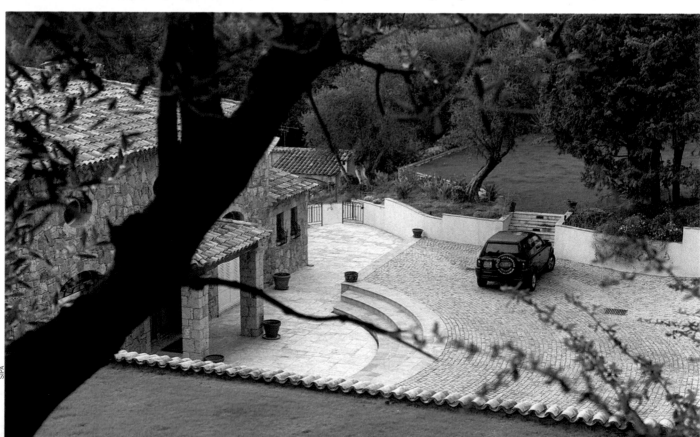

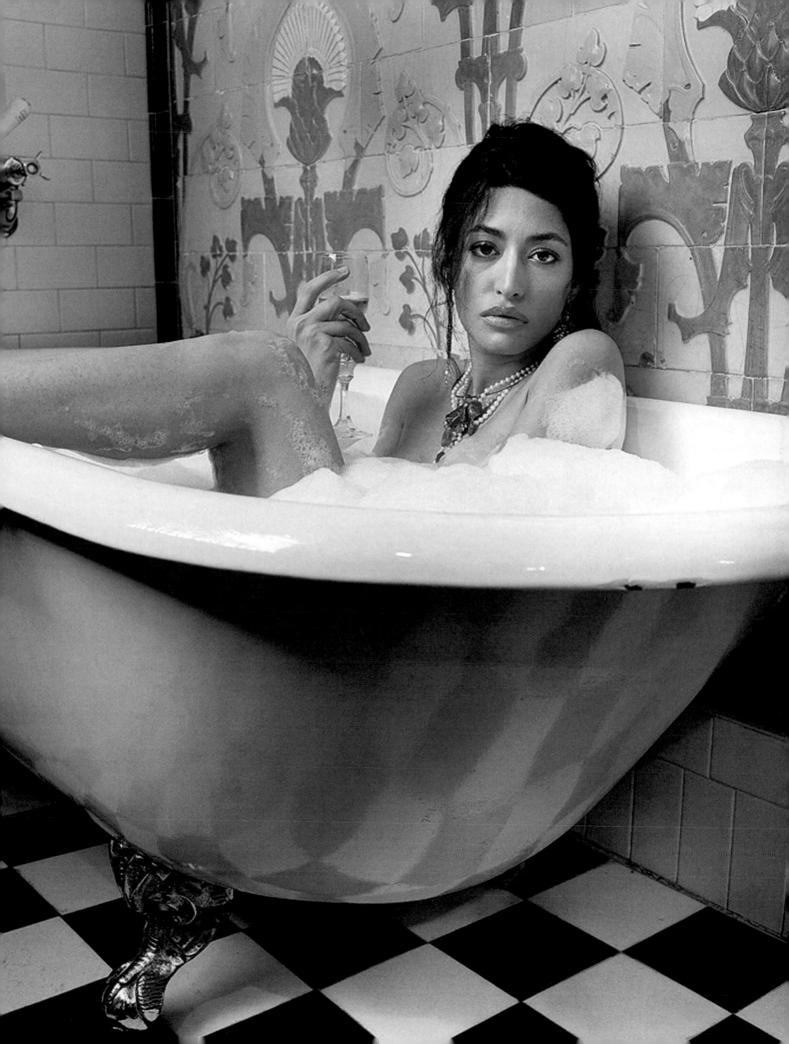

If it is sometimes problematic or confusing to be a sibling of the late Osama bin Laden, it is even more so to be an offspring—particularly if one chooses to live outside the relative shelter of the radical Islamic community. Omar bin Laden, seen here riding with his British-born wife, Zaina Alsabah—the former Jane Felix-Brown—was born in 1981, the fourth son of Osama and his first wife (and first cousin), Najwa Ghanem. Omar and his mother co-wrote a book in 2009 entitled *Growing Up bin Laden,* in which they detailed how "the kids grew up in Saudi Arabia, Sudan and Afghanistan without laughter or toys, were routinely beaten, and lost their pets to painful death from poison gas experiments by their father's fighters." The family lived in Jedda, Saudi Arabia, then moved to stone huts in Tora Bora that had no electricity or running water. According to the book, Omar's father asked him to volunteer for suicide missions.

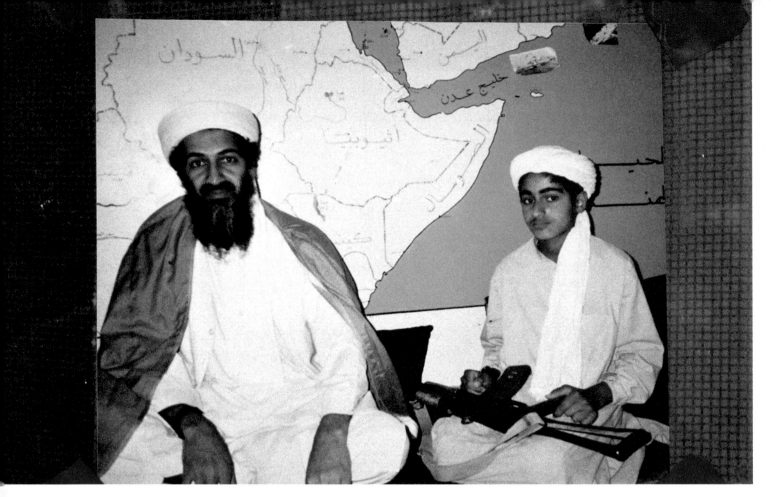

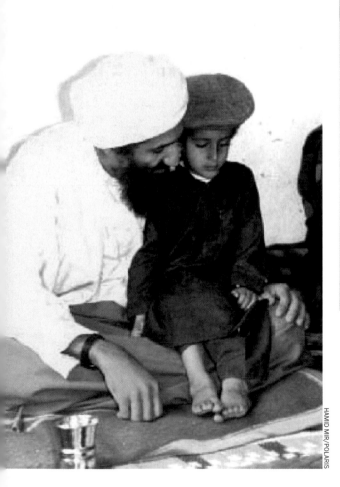

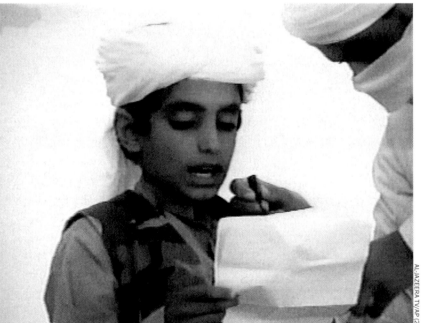

Muhammad bin Laden, born poor, had founded a phenomenally successful business and had sired an astonishing number of sons and daughters. Whether Osama bin Laden felt in any way competitive with his father is best left to the psychologists, but he too, as we know, founded an organization, married several times and had many children. On the pages immediately previous we learned that he encouraged his boy Omar to make the ultimate sacrifice for Islam. Here we see that, not unlike Muhammad, he encouraged all his sons to follow in their father's footsteps. Opposite, counterclockwise from top: He and one of his boys in an undated photo that was released after the 9/11 attacks; a like photograph; and an Al-Jazeera TV image of Hamza bin Laden, who was born in 1989 to bin Laden's third wife, at a family fete, reading a poem defending his father. Below: In January 2001, Osama beams at his son Mohammed, who was born in 1985 and is being wed this day to the daughter of Osama's aide Mohammed Atef (left). The subsequent history of Hamza in particular is interesting: Video footage released through the years has shown him fighting alongside the Taliban, and by 2007, it was reported that he, not yet 20, had taken a senior role in al-Qaeda. In 2008, his incendiary poetry ("accelerate the destruction of America, Britain, France and Denmark . . .") was published on an extremist Islamic Web site, and although it is unconfirmed as our book goes to press, it has been reported that he might have been the son killed during the raid on the Abbottabad compound on May 2, 2011.

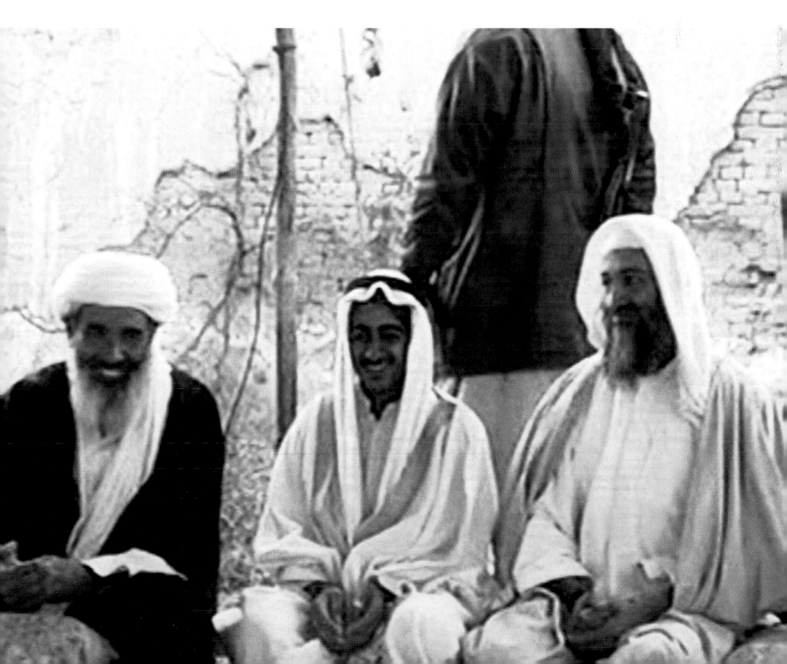

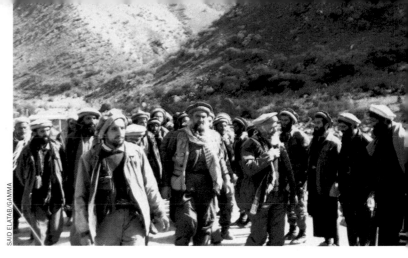

It is hard to overestimate the influence of Abdullah Azzam (opposite) on the thinking and career of Osama bin Laden. The former university lecturer and leader of the Palestinian Muslim Brotherhood lured bin Laden to the Afghan conflict. Together in 1984 they founded the Maktab al-Khidamat, the Afghan Services Bureau, to raise funds and recruit foreign mujahideen for the war against the Soviets. In 1988, bin Laden founded al-Qaeda, but this was really just a morph of the earlier organization; its objective—a widespread radicalization of existing Islamic groups and the creation of radical organizations where none existed—was certainly a longtime goal of Azzam's. It can be said that the scholarly theologian, even more than bin Laden himself, is the Muslim leader most responsible for expanding jihad into a full-blown international holy war without borders—and this claim doesn't refer only to his influence in al-Qaeda. Although Azzam himself was assassinated in 1989, a group calling itself the Abdullah Azzam Brigades claimed responsibility for killing 34 in the October 2004 bombings at the Egyptian resorts of Taba and Ras Shitan; for killing more than 80 in bombings in the resort town of Sharm al-Sheikh on July 23, 2005; and for the attack on July 28, 2010, against a Japanese tanker sailing in the Gulf of Hormuz. Azzam was, as bin Laden would become in his absence, an inspiration to like-thinkers. With his protégé (right, in Afghanistan in 1984), they were formidable in rallying troops during the Afghan War (top), and thanks to his protégé's wealth and the help of allied Americans, they built a formidable store of weaponry (below, bin Laden at far right).

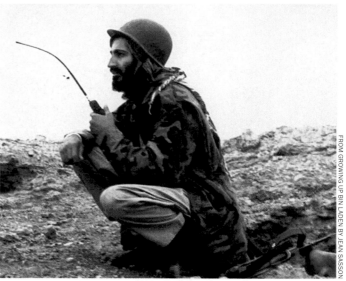

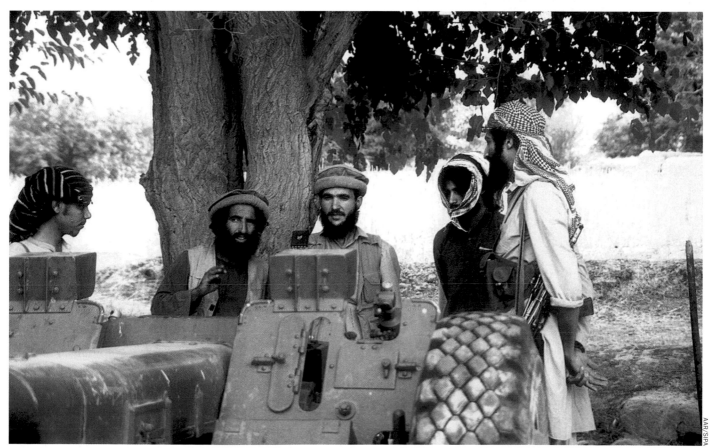

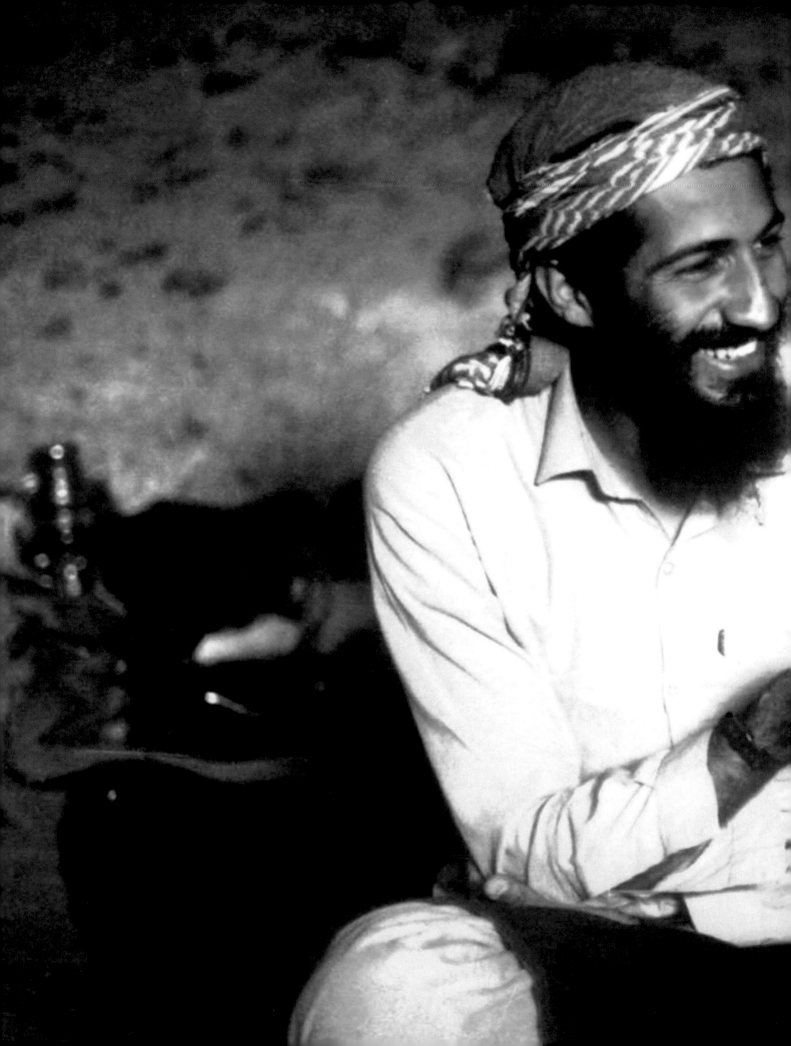

Bin Laden smiles broadly in a cave in the Jalalabad region of Afghanistan in 1988. Even more than in the aftermath of 9/11, these were the heady days for this young man, barely older than 30. The war against the Soviets was in its ninth year, and the tide was turning in favor of the Afghan Arabs. Bin Laden's hero, Abdullah Azzam, was still alive. Their organization was enjoying fantastic success in enlisting thousands of young, disaffected Muslims (it was in this year that bin Laden translated this boon into "the base": al-Qaeda). And he himself had grown into a legend—to some, a messiah. He was already styling himself as a latter-day prophet, a modern Muhammad, and to his ardent followers there seemed no blasphemy in this. Bin Laden, in 1988, believed all was possible, and convinced other radicals that this was so.

t is hard for an American to appreciate what a land of constant violence Afghanistan has been in recent world history. The Soviets invaded to quell Arab uprisings in 1979, and nothing has been remotely calm since. Today, of course, war continues to rage, and the U.S. is now involved (as indeed it was back in the 1980s, at that time in opposition to the Soviets). So: more than 30 years of war—some of it waged on religious grounds and some clearly to express political grievances. Which brings us to a term already used in these pages: *mujahideen*. It is Arabic for "strugglers" or "fighters" or "people waging jihad"—and it was a powerful word in the war against the U.S.S.R. The United States gave these mujahideen forces sophisticated weaponry, and they put it to effective use (below, left). There is one historical figure who, even more than bin Laden—in fact, much more than bin Laden—puts in relief the disparate factions and aspirations of the various Muslim groups at play in Afghanistan then (and now), and he is Ahmad Shah Massoud (below, far right),

the Lion of Panjshir, the devout Sunni Muslim and former engineering student credited as the greatest military leader of the resistance against the Soviets. ("[T]he Afghan who won the Cold War," according to the *Wall Street Journal.*) Massoud was the main man during the war, but he always detested the radical Islamic interpretations held by the Taliban and al-Qaeda, and with the ascendancy of those groups in the wake of the Soviet defeat, he was compelled to return to the opposition. Two days before 9/11, he was assassinated in Afghanistan by suicide bombers believed to be from al-Qaeda. Today, with the Taliban having been deposed, September 9 is a national holiday called Massoud Day. Back then, the fight that Massoud led was reaching conclusion in March of 1989 at the Battle of Jalalabad (bottom). And yet Afghanistan, as Massoud's killing indicates, still would not find true peace even with the Soviets' exit. Opposite is a woman with her sleeping child hunkering by a mujahideen tank near Kabul in 1992.

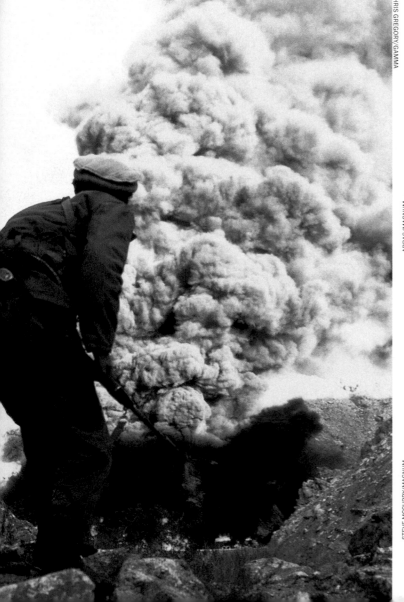

CHRIS GREGORY/GAMMA

ABBAS/MAGNUM

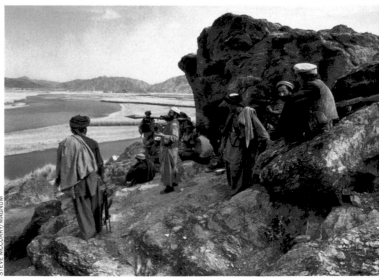

STEVE MCCURRY/MAGNUM

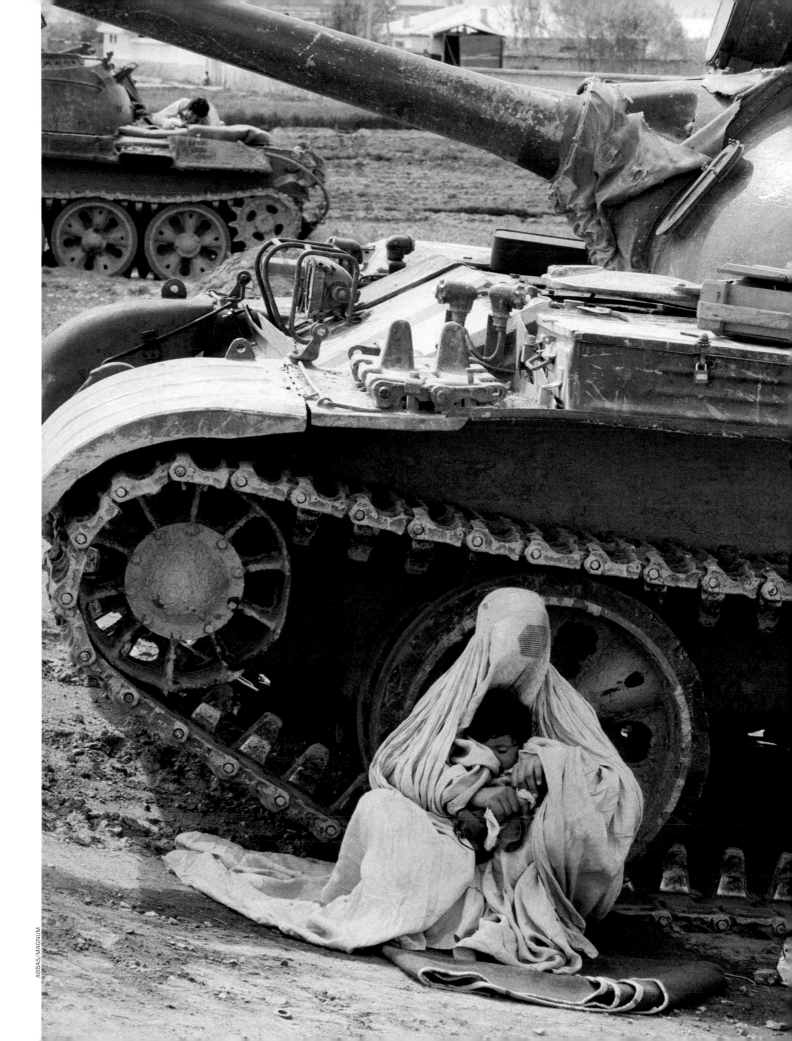

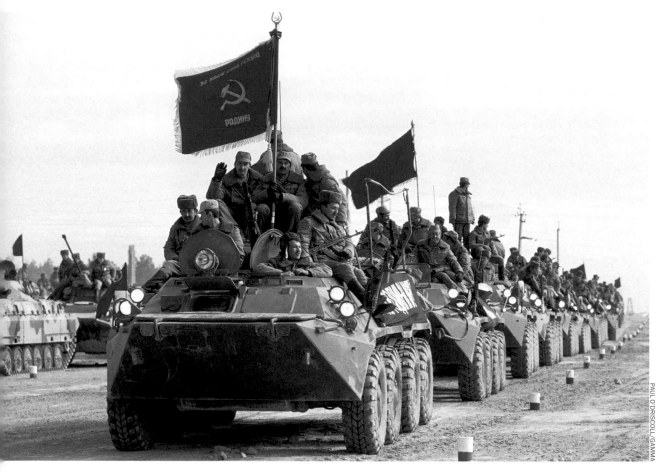

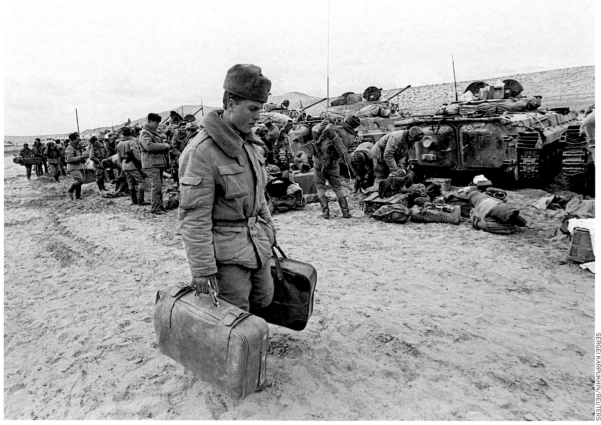

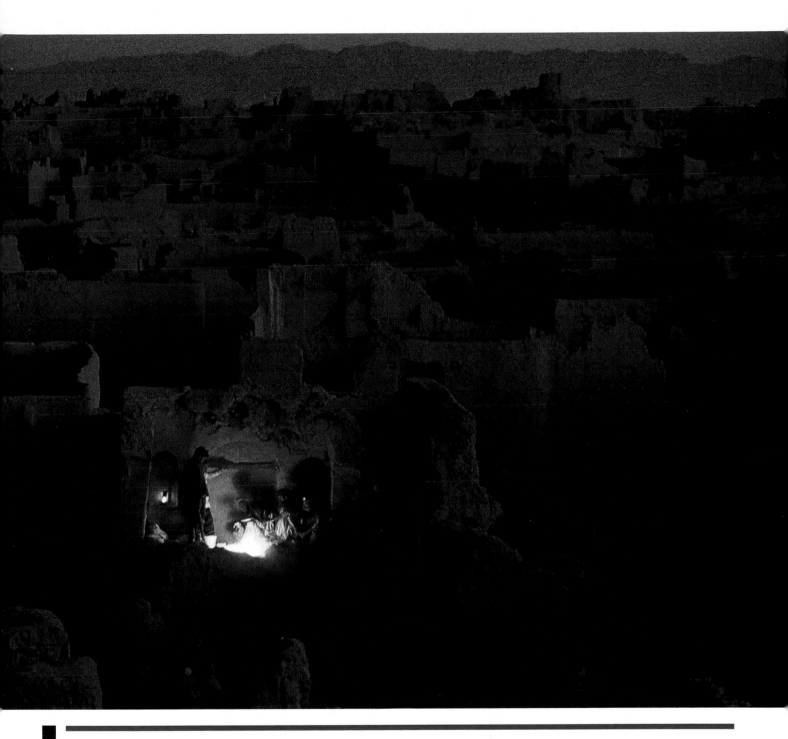

Its interventionist war in Afghanistan, which lasted a decade, has often been called "the Soviet Union's Vietnam," and the term is apt. The U.S.S.R.'s armed forces became mired in a conflict with an intransigent opponent that was powered by the high-octane fuel of nationalism (not to mention religiosity, and not inconsequentially armaments supplied by the Soviets' counterpart "world power," the United States). The difference between Vietnam (for the U.S.) and Afghanistan (for the U.S.S.R.) was that the Soviets were not well-situated, economically or militarily, to withstand the immense drain, and once they withdrew their forces in 1989, after the loss of perhaps as many as 15,000 soldiers (and the death of untold numbers of Afghan citizens), the Soviet Union was poised to be challenged—and to crumble. Opposite: Among the Soviets beating a retreat are tanks (top) and a soldier bearing luggage to a train station near the town of Termez in Uzbekistan, barely 20 miles from the Afghan-Soviet border. Above: The Afghan city of Herat tries to rebuild after years of Soviet bombardment. Afghanistan had won, in a fashion, but was, like the U.S.S.R., vulnerable. It was set up for the dominance of the Taliban and Taliban allies such as bin Laden.

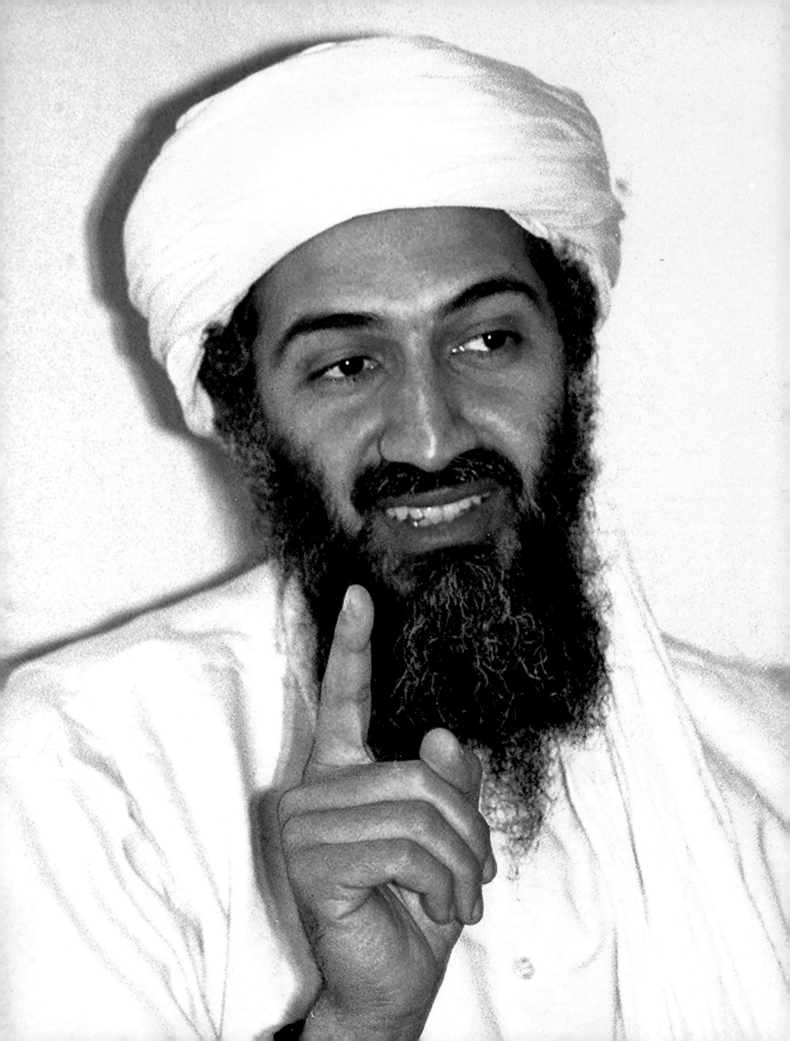

Bin Laden, speaking to a French journalist in 1995, insisted that he had never politically, philosophically or emotionally allied with the United States during the war in Afghanistan, and that he had become, in this intense period, more clear-eyed about the true identity and universality of the devil: "For us, the idea was not to get involved more than necessary in the fight against the Russians, which was the business of the Americans, but rather to show our solidarity with our Islamist brothers. I discovered that it was not enough to fight in Afghanistan, but that we had to fight on all fronts against communism or Western oppression. The urgent thing was communism, but the next target was America."

Yes, bin Laden was as adept at revisionist history as he was at self-mythologizing—often, in his case, the same thing—but certainly by 1995 it was indeed the United States, his former ally no matter how he chose to parse it to satisfy his updated résumé, that was in his crosshairs. If, as professed, he had long loathed the secular, capitalistic U.S., the event that amounted to true blasphemy in his mind had occurred in the interim between the end of the Afghanistan war and the beginning of his career as a no-holds-barred terrorist—and really, what the event amounted to was that he had been dissed. In 1990, what we know as "the first Gulf War" was begun when Saddam Hussein's Iraq invaded Kuwait, and the United States rushed into the fray. The entire Middle East was on tenterhooks. Bin Laden, now a populist hero in his homeland, went to the Saudi leadership and said he could and would defend the kingdom with the military force that he had developed in Afghanistan. He was told by the royals: Don't worry, the Americans are defending us. Bin Laden became convinced that Washington wanted to govern—rule—the entire world, including and perhaps especially the Arab and/or Islamic world, and he grew incensed that American boots were on the ground not only in Kuwait and Iraq but in Saudi Arabia. He said it out loud: The infidels are invading, everywhere.

The Saudi regime tried to marginalize, unto censoring, the increasingly vociferous bin Laden so that he would not offend its American allies, and so bin Laden eventually absconded and set up shop in Sudan, the of-the-moment hospitable redoubt of terrorists. Once his al-Qaeda

Once he was in charge, the attitude reflected in the photograph on the opposite page—lecturing, hectoring, arrogant, not to be questioned—became constant, especially in the imagery that bin Laden chose to disseminate to the world at large.

AFP

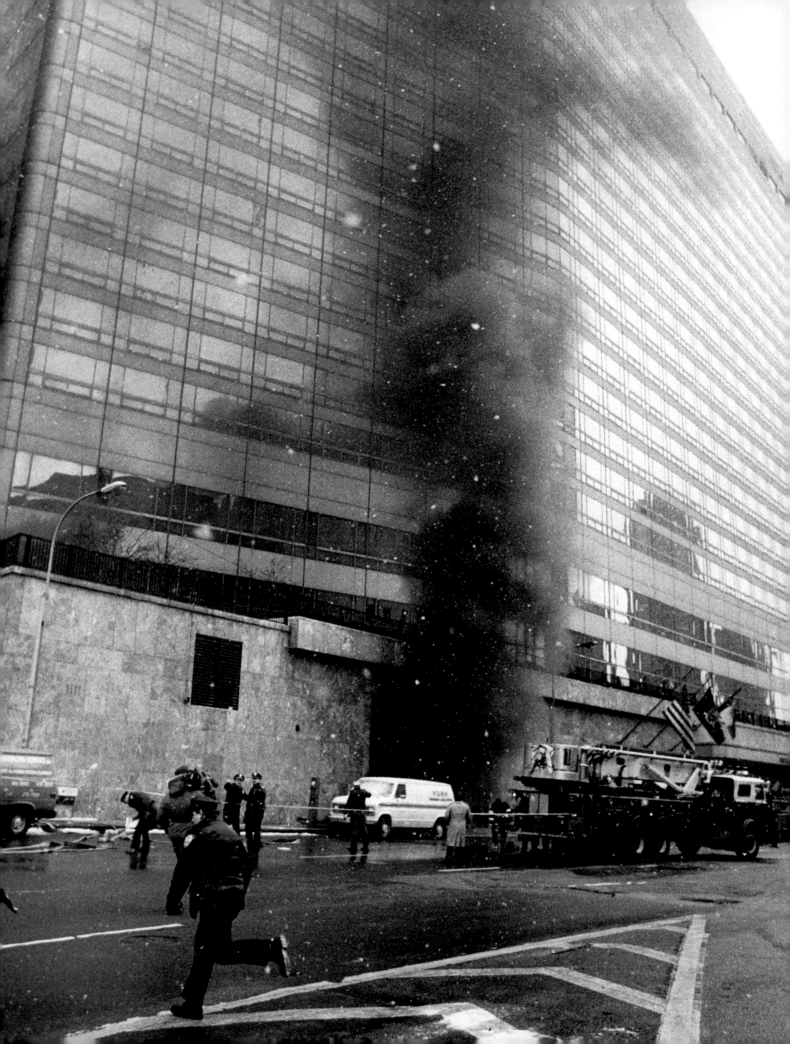

Mastermind

(Arabic for "the base," which reflects its loose-gathered nature) gained too much notoriety—became simply too hot—Sudan, also, ushered bin Laden out. From there, his future looked to be Afghanistan.

A fundamentalist Islamic group called the Taliban ruled that country in the mid-1990s, and bin Laden was plenty friendly with its leader, Mullah Muhammad Omar. Bin Laden was readily, even warmly, welcomed. Al-Qaeda was every bit as transportable as bin Laden himself—it was imagined from the day of its naming as a network, a society, a whispered organization of ruthlessly determined like-minded leaders and cells—and once he had reestablished this muscular terrorist operation in Europe, he was ready to wreak true havoc.

Awful things had already been happening, and they grew more awful by the year; many of these events can be traced, now, to al-Qaeda. To reemphasize: The Base was always and remains a loose organization, which any terrorist can join simply by volition, so it is difficult to attribute specific attacks with certainty (bin Laden claimed credit for none before 9/11), but it is credited by experts that the first al-Qaeda assault was the December 29, 1992, bombing of a hotel in Aden, Yemen, which was a stopover for American troops headed for Somalia. The fatalities were two Austrian tourists, who can now stand as the initial instances of collateral damage routinely caused by al-Qaeda—never a concern, seemingly, and in opposition to Islamic teaching. On February 26, 1993, the bomb that eventually put Ramzi Yousef away for life (and that meanwhile killed six people) exploded under the World Trade Center. Eight months later, 18 American service members were killed in Somalia. In November of 1995, seven died when a truck bomb exploded at the National Guard training center operated by the U.S. in Saudi Arabia. In June of 1996, 19 soldiers were killed when a truck bomb was aimed at an American military residence in Dhahran, also in Saudi Arabia. On October 12, 2000, the United States Navy destroyer USS *Cole* was harbored and refueling in the Yemeni port of Aden when two suicide bombers gave up their lives, claiming 17 American sailors in the measure and injuring 39 others. This was the deadliest attack against a U.S. naval vessel since 1987.

But 9/11 still awaited. And Osama bin Laden, an energetic terrorist, was planning his next move.

Smoke billows from the World Trade Center in New York City following the terrorist bombing attack of February 26, 1993. In this early instance of an assault on lower Manhattan, an enormous truck bomb was detonated in a garage beneath the North Tower of the World Trade Center, in hopes that the building would fall into the South Tower and bring both crashing to the ground.

Osama bin Laden was not the mastermind of the 1993 World Trade Center bombing, but a young man who had trained at his al-Qaeda facilities in Afghanistan and had been inspired by bin Laden's persona was. Ramzi Yousef (right), a native of Kuwait, began planning a bombing attack in the United States in 1991 with the intention of pressing Washington to cease its active backing of Israel and desist in all activity in Arab affairs. He was encouraged in his plans by an uncle, Khalid Shaikh Mohammed, who a decade later would be seen as the principal architect of bin Laden's September 11 attacks on, among other places, the same Twin Towers. Mohammed gave Yousef seed money, and in September 1992, Yousef entered the United States. He gathered coconspirators in New Jersey, and at one point phoned the controversial radical and charismatic blind Muslim cleric Omar Abdel Rahman (below), who allowed Yousef's gang to do its bomb-making at his Al-Farooq Mosque in Brooklyn. Yousef and Abdel Rahman are both serving life sentences for their parts in the plot, which killed six people (and an unborn infant) and injured over a thousand. Opposite, on a street outside the World Trade Center complex an evacuee gasps for breath (top) and survivors of the terrorist attack embrace. Such scenes from the precise same location would be repeated a thousandfold on 9/11, and would be etched in the memories of all Americans.

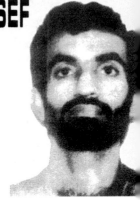

The United States Department of State is offering a reward of up to $2,000,000 for information leading to the apprehension and prosecution of YOUSEF. If you have information about YOUSEF or the World Trade Center bombing, contact the authorities, or the nearest U.S. embassy or consulate. In the United States, call your local office of the Federal Bureau of Investigation or 1-800-HEROES, or write to:

HEROES
Post Office Box 96781
Washington, D.C. 20090 – 6781
U.S.A.

RAMZI AHMED YOUSEF
DESCRIPTION

DATE OF BIRTH: May 20, 1967 and/or April 27, 1968
PLACE OF BIRTH: Iraq, Kuwait, or United Arab Emirates
HEIGHT: 6'
WEIGHT: 180 pounds
BUILD: medium
HAIR: brown
EYES: brown
COMPLEXION: olive
SEX: male
RACE: white
CHARACTERISTICS: sometimes is clean shaven
ALIASES: Ramzi A. Yousef, Ramzi Ahmad Yousef, Ramzi Yousef, Ramzi Yousef Ahmad, Ramzi Yousef Ahmed, Rasheed Yousef, Rashid Rashid, Rashed, Kamal Ibraham, Kamal Abraham, Abraham Kamal, Muhammad Azan, Khurram Khan,

UPI/LANDOV

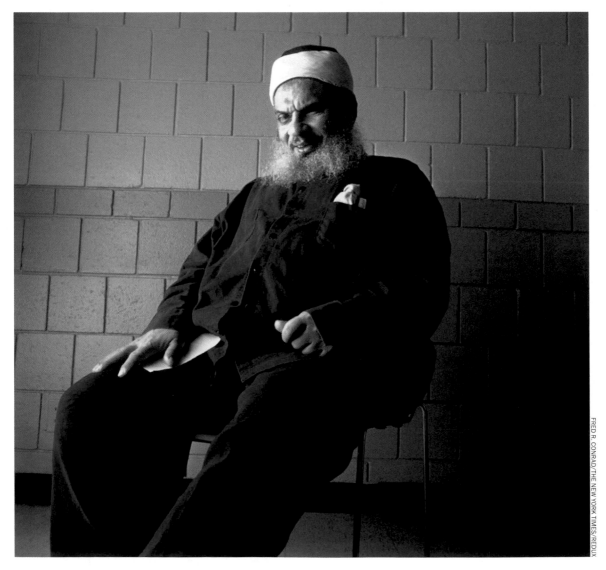

FRED R. CONRAD/THE NEW YORK TIMES/REDUX

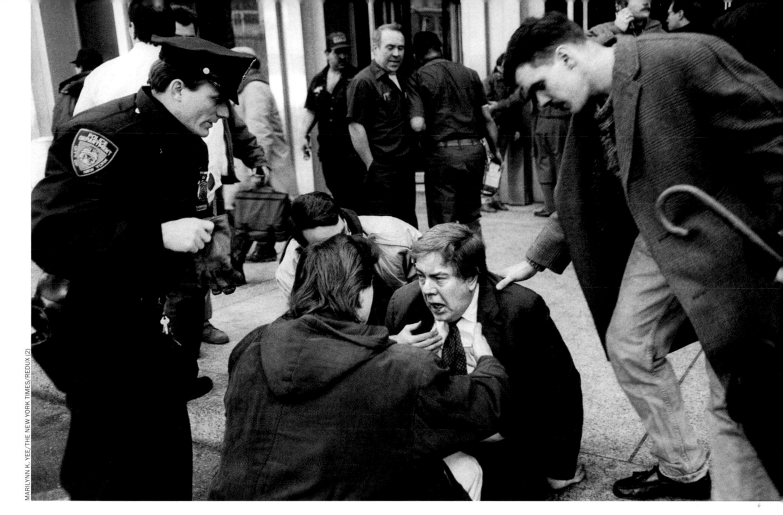

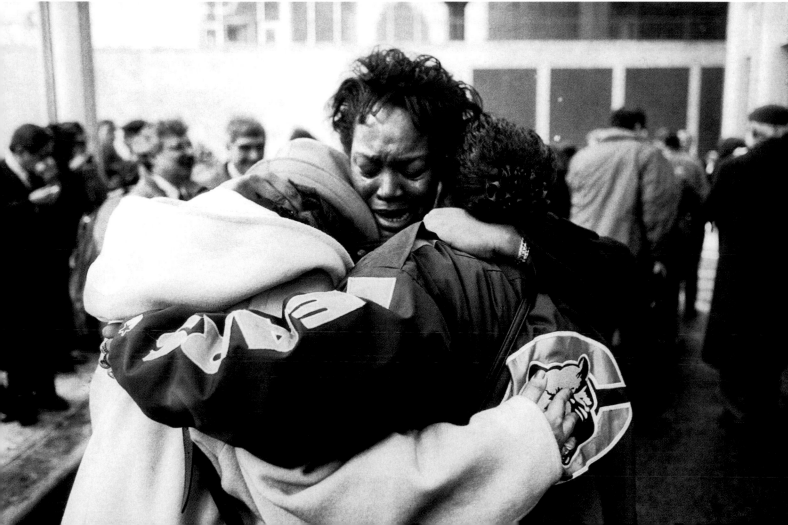

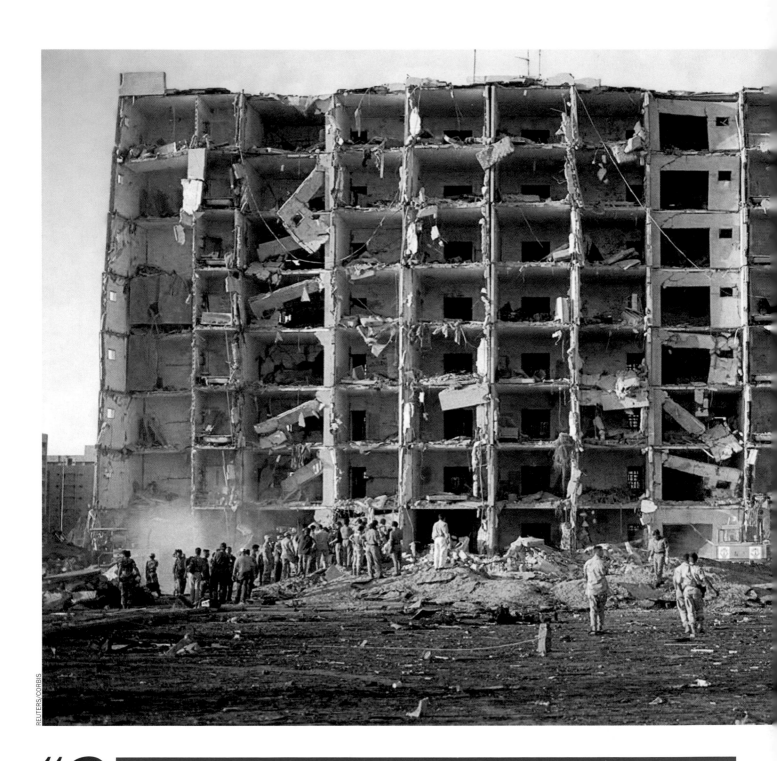

"Collateral damage" was not a term that resonated with Osama bin Laden or his followers; all fatalities were seen as justified. In several cases before 9/11, the targeted victims were often United States service members stationed in or headed for the Middle East, but innocents died too. Examples include the bombing of the Khobar Towers in Dhahran, Saudi Arabia, a de facto barracks that housed many foreign military personnel. Killed in that attack in June 1996 (above) were 19 Americans. Another attack on the United States embassy in Nairobi, Kenya, on August 7, 1998 (opposite)—one of several nearly simultaneous truck-bomb blasts that killed 224 in that city and in Dar es Salaam, Tanzania—claimed scores of Americans.

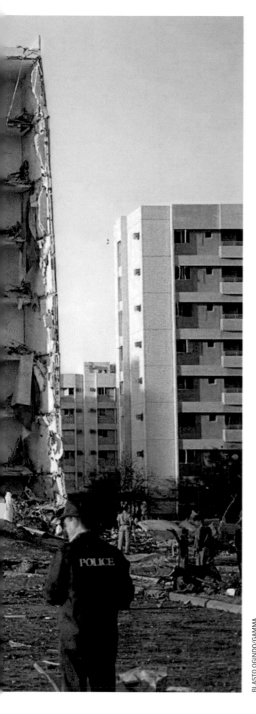

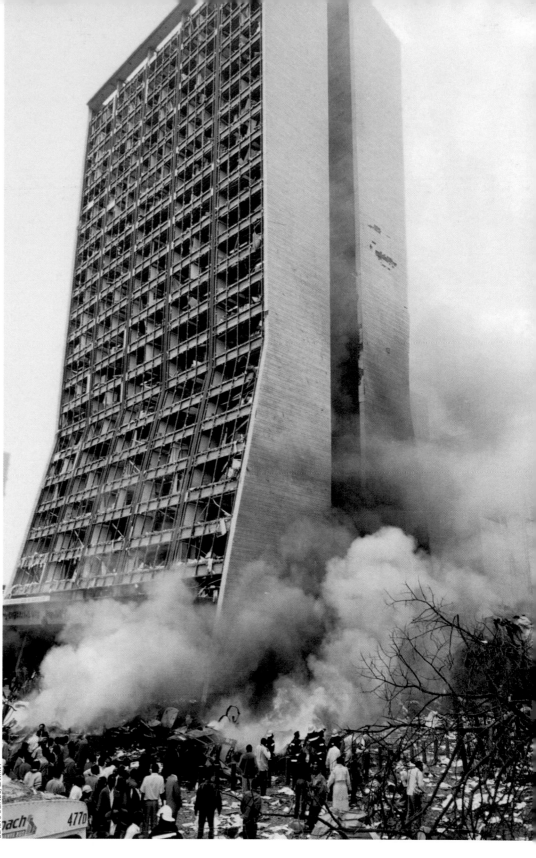

BLASTO OGINDO/GAMMA

At the Khobar Towers, 372 people of many different nationalities were wounded, and in Kenya and Tanzania the attacks might have had a professed goal of wounding Washington, but the violence was indiscriminate. Although bin Laden was already being watched by U.S. intelligence, the embassy bombings landed him and his confrere Ayman al-Zawahri on the pages of many American newspapers for the first time, and also caused bin Laden to be placed on the FBI's Ten Most Wanted List, where he would remain for 13 years. A footnote: In these years, al-Qaeda was often seen as a coconspirator—linked with the militant Palestinian Hezbollah organization in Dhahran, and with the Egyptian Islamic jihad in Dar es Salaam and Nairobi.

From 1998 on, bin Laden and his chief lieutenants were in the crosshairs, even if the citizen in the street, or even the devout listeners of talk radio, wouldn't twig to this for another three years. Right: By May of that year, he and his number two, al-Zawahri, were of sufficient interest to CNN that the news channel acquired a cache of videotapes in Afghanistan that feature them plotting in one of several camps operated by bin Laden near the southeastern Afghan town of Khost, which was at the time one of the principal areas where U.S. forces were searching for Taliban and al-Qaeda fugitives. At a news conference on May 26 of that year, bin Laden warned of a mission that would "result in killing Americans and getting rid of them." The U.S. Defense Department was engaged in aerial surveillance of some of al-Qaeda's training sites, and on August 20, President Bill Clinton ordered missile strikes on the Zhawar Kili Al-Badr camp in Afghanistan (below) and on Sudanese facilities believed to be associated with the earlier bombings of the two U.S. embassies in East Africa. Opposite, top: Damage of an al-Qaeda facility in the wake of the embassy-bombing reprisal raids. Bottom: The ruins of the al-Shifa pharmaceutical plant in Khartoum North, Sudan,

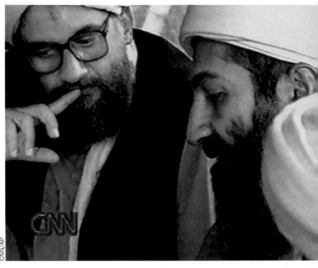

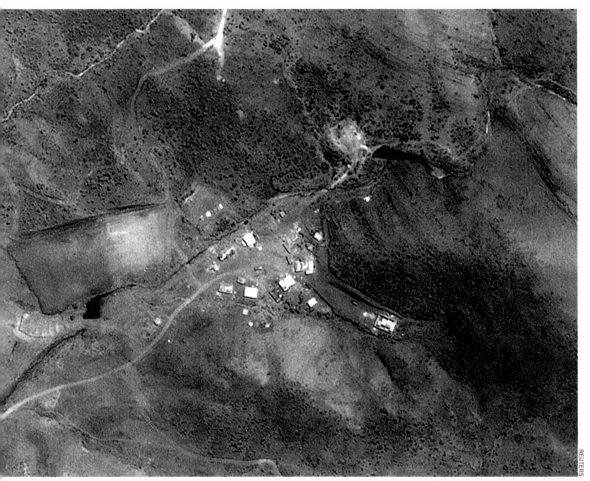

which was also destroyed by a U.S. missile attack in 1998. One employee was killed, several were wounded and, according to critics of the attack, many Sudanese died because they were denied the antimalarial and other medicines that the factory was producing. The allegation by Washington countered that al-Shifa was bankrolled by bin Laden, was manufacturing chemical weapons, including something called the VX nerve agent, and that Sudan and private firms in the region should start disassociating themselves from people who were blowing up U.S. embassies.

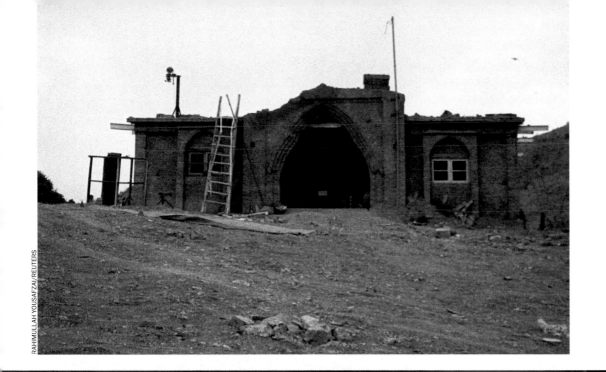

Osama bin Laden always thought of al-Qaeda as a free-association organization: folks in touch with one another electronically or informally (or even anonymously), united by the common goal of beating the devil. But from January 5 to January 8, 2000, there was a face-to-face summit meeting of al-Qaeda honchos in Kuala Lumpur, Malaysia. Some of the men who would be involved in 9/11 were in attendance, and among the plans they discussed was how to sink a U.S. ship. They were particularly engaged in this because only a few days earlier the organization's attempt to cripple the U.S. Navy destroyer USS *The Sullivans* had gone badly. The vessel had been docked in Aden, Yemen, as hoped, but the al-Qaeda boat that was supposed to be detonated alongside was so full of explosives that it sank under the weight. Ten months later, on October 12, the suicide attack on the destroyer USS *Cole*, also in Aden harbor for a routine refueling, went off more successfully for the terrorist group. The blast into the hull of the boat (right) was felt just as the crew was lining up for lunch. Bin Laden later used photos and videos of the *Cole* incident in al-Qaeda recruitment videos. Below: Richard Danzig, secretary of the Navy, is clearly distraught as he discusses events with the Pentagon from a phone booth on Wake Island in the South Pacific on October 13. Opposite: A mother enjoys a tearful reunion with her daughter, one of the 39 sailors injured; a boy pays respects; and one of the 17 dead is borne forth.

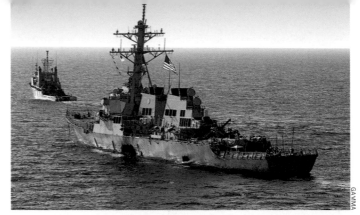

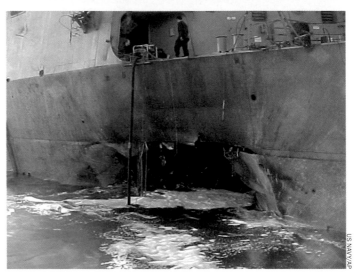

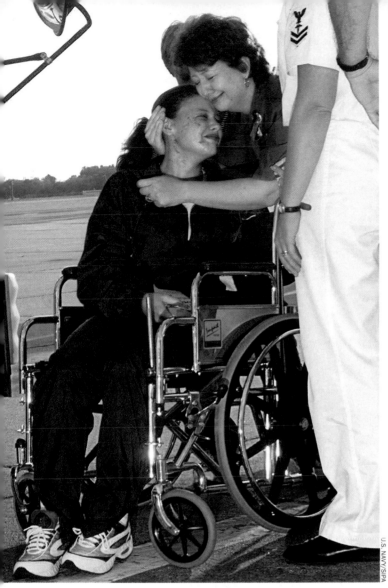

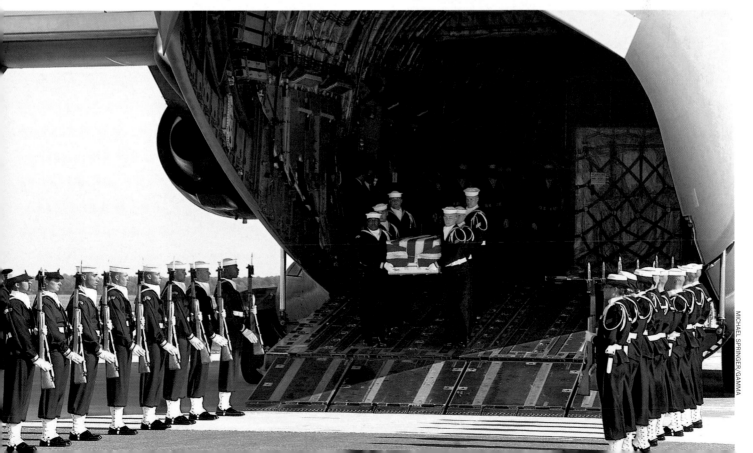

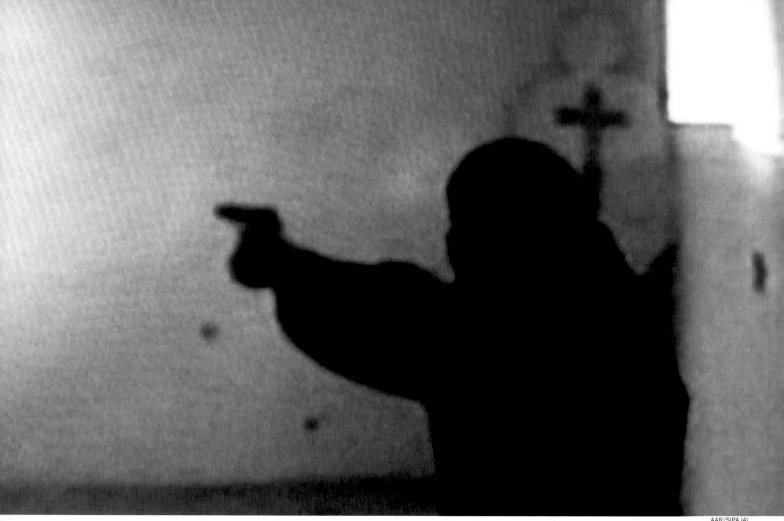

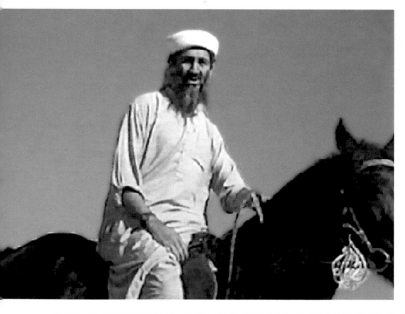

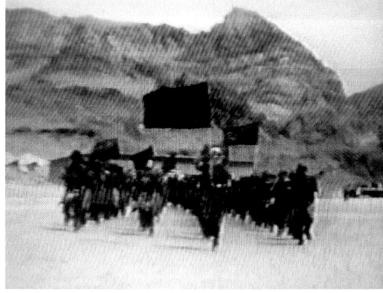

This is al-Qaeda, including its leader, in training; these photographs are thought to date from the spring of 2001 (except, of course, for the one showing Bill Clinton as a target—since his administration had ended in January of that year. But then again, al-Qaeda may have been using old footage). On this page, clockwise from top, three images believed to have been taken on June 19, 2001, show bin Laden practicing his aim, his troops marching forcefully with fearsome flags, and then him presiding from horseback à la Napoleon or Lawrence of Arabia. Opposite, clockwise from top left: A chilling image from April of 2001 made at the Mir Bacha Kot camp on the Shomali Plain in Afghanistan, which shows al-Qaeda operatives practicing commando missions in which they will enter residential compounds and take hostages to bring their jihad to the West; the Clinton target practice session; and physical training that might be normal in any army.

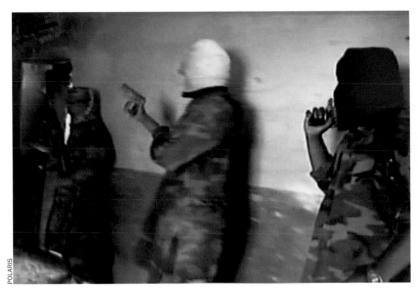

POLARIS

GAMMA

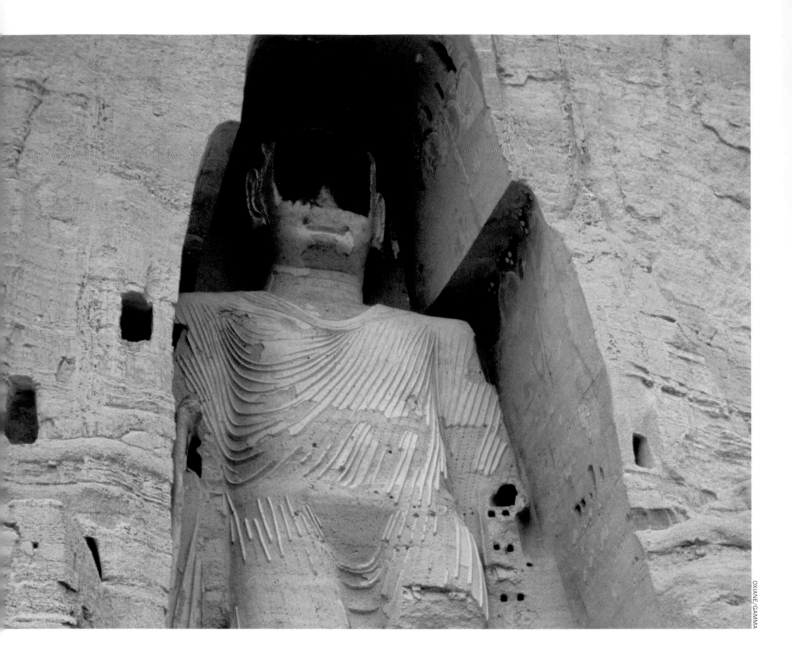

What al-Qaeda stands for in terms of religion—or stood for when bin Laden founded it—is surprisingly difficult to parse. The short answer has always been "radical Islam." That might be the truest answer, too. But from the first, bin Laden aligned himself with those who could help him, the secular and non-secular, this denomination or that, whoever had the money, guns or hideout. Although he was far more concerned with Saudi Arabia in the mid-1990s, he said "sure" to Hezbollah and its complaints against Israel. Even earlier, while he fought against the Soviets, he shook hands with Americans. When he took up against the Americans, Egyptian jihadists seemed his best friends. Whether his affiliations were forged by faith or politics will be debated in a thousand biographies yet to be written. His most fateful alliance was with the Taliban, which offered him safe harbor—and a future—in Afghanistan. This "radical Islamist" organization

was in control of the country when bin Laden, exiled from Saudi Arabia and Sudan, began establishing his base of al-Qaeda operations there. Very quickly, there was an allegiance. Both the Taliban and bin Laden claimed to be guided, day to day, by deeply held religious precepts. Maybe that's right, but certainly what was shared seems to be a mutual hatred of everything and everyone else. More than 1,500 years ago, two giant Buddhas were hewn into a cliff in the Afghan province of Bamiyan with incredible, superhuman toil. In the spring of 2001, it took the Taliban 20 days to very purposefully destroy them. Did Osama bin Laden exult that day? Did he have any opinion at all about Buddhism? The thinking is: He was safe in Afghanistan, content with that, and planning an imminent attack on the United States of America—an attack that he would dress as a holy war, maybe even convincing himself that this is what it was.

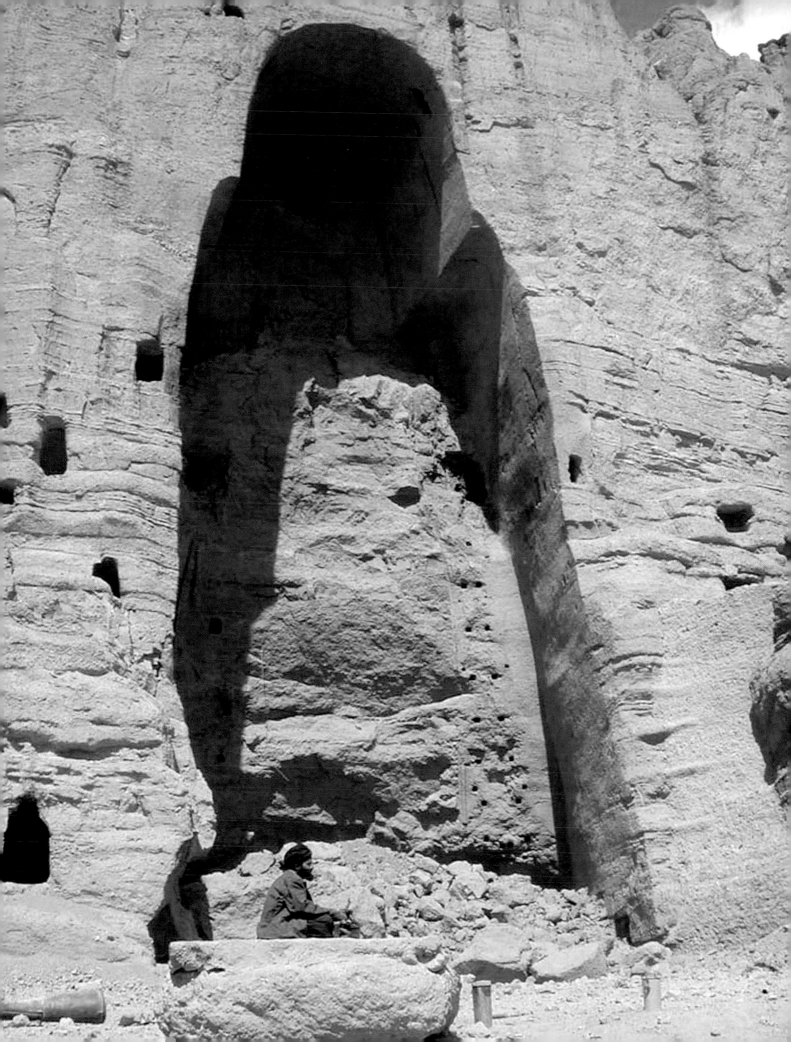

We have seen, in our book's first chapter, the crime—the attack; the act of war—that defined Osama bin Laden at the time, and always will define him. We have seen the violence and the destruction. Here, in three sets of photos, are some of his al-Qaeda operatives as they go into action that September morning. Below, left: On the surveillance tape at a Fast Green ATM in the parking lot of an Uno restaurant in Portland, Maine, Mohamed Atta (background, top left) and Abdulaziz Alomari are seen on a security camera video the day before the attack. Below: On the morning of 9/11, Atta (right) and Alomari clear security before flying from Portland to Boston, where they will board American Airlines Flight 11. Right, from

Fast Green ATM
9/10/01

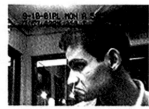
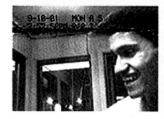

8:41 pm

**UNO's Restaurant Parking Lot
280 Maine Mall Road
South Portland, ME**

top: Atta, Alomari and Zacarias Moussaoui. This third man is a curiosity: A French citizen of Moroccan descent, he is seen here in his mug shot at the Carver County Sheriff's Office in, of all places, Minnesota. He is a would-be hijacker, also in thrall to bin Laden, who didn't make it on September 11—the failed hijacker, who is being held as such, probably for the rest of his life.

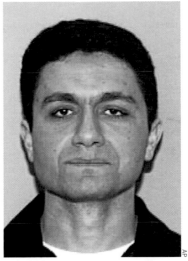

AP

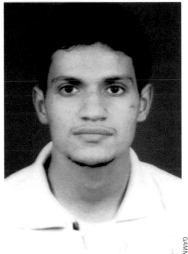

GAMMA

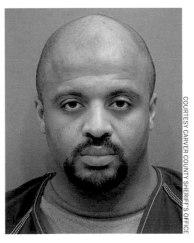

COURTESY CARVER COUNTY SHERIFF'S OFFICE

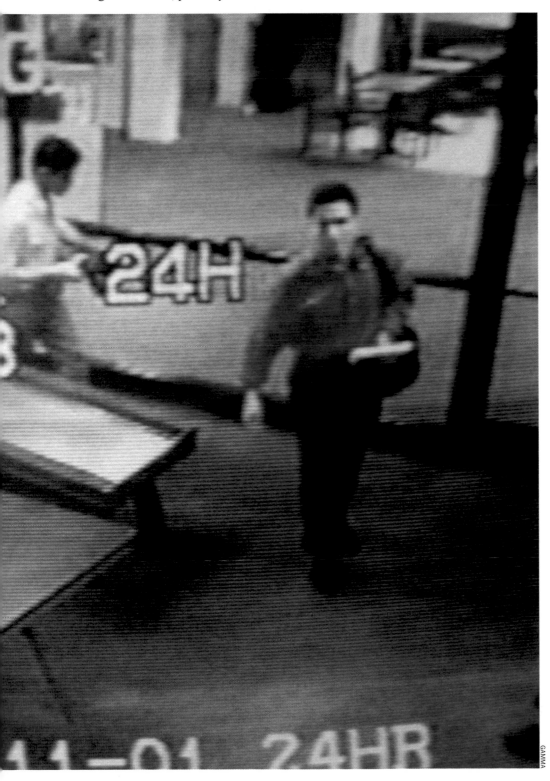

GAMMA

The fate of the Twin Towers is known to all. But bin Laden hoped for more: He wanted, on that brilliantly beautiful September morning, to affect the fate of the United States. Emboldened by his success against the Soviets in Afghanistan, he truly felt superpowers could be toppled. But, despite the turmoil and confusion of the first hours of 9/11, the questions were soon framed: Who was going to rise? And who, really, was on the run?

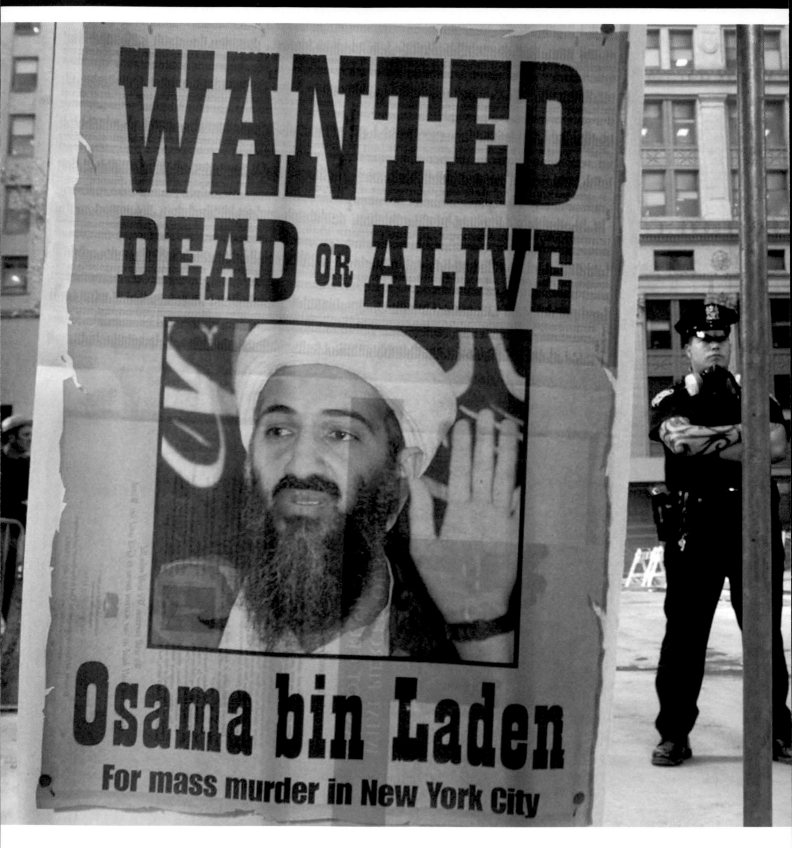

Fugitive

SIX DAYS AFTER THE ATTACKS, PRESIDENT GEORGE W. Bush was asked, "Do you want bin Laden dead?"

It was a forthright question, and the President gave a forthright, vigorous answer: "I want justice. And there's an old poster out West, as I recall, that said, 'Wanted: Dead or Alive.'"

Without question he spoke for most of his countrymen at that time, and certainly he felt at that time that bin Laden would be caught. It would prove grating—painful—for the President and his country that this terrorist proved so elusive, and it is particularly upsetting in retrospect that U.S. forces came so close to sealing the deal even before 2001 had ended. It has been estimated that hundreds of thousands of noncombatant civilians worldwide have been killed since the War on Terror instigated by 9/11 was launched. How many might be alive today had Osama bin Laden been taken out in Tora Bora three months after the attack on America will never be known.

Tora Bora is, for lack of a better way to understand it, a warren of caves in the mountains of northeastern Afghanistan with military infrastructure that had been built with the help of the CIA for the mujahideen during the Afghan war against the Soviets. There is no doubt that this was one of bin Laden's first hideouts after the U.S. launched Operation Enduring Freedom in the wake of 9/11. Afghan, American, British and German forces descended upon the region in the Battle of Tora Bora in December of 2001, and U.S. bombers pounded the mountains for days. It is probable that there were never more than 300 al-Qaeda operatives in the region at the time, and maybe a few more than a dozen Kalashnikov rifles, but bin Laden was indeed among the fugitives. He wasn't sure where he was headed, he confided at the time, but realized that he had to keep moving. Somehow he did. Retrospective criticism holds that U.S. Army general Tommy Franks's reluctance to commit even more troops and firepower to the battle, probably influenced by Washington's looming plans to intervene in Iraq, allowed bin Laden to escape to Pakistan, "one of the greatest military blunders in recent U.S. history," wrote Peter Bergen in a cover story for *The New Republic,* "The Battle for Tora Bora." When the United States turned its attention

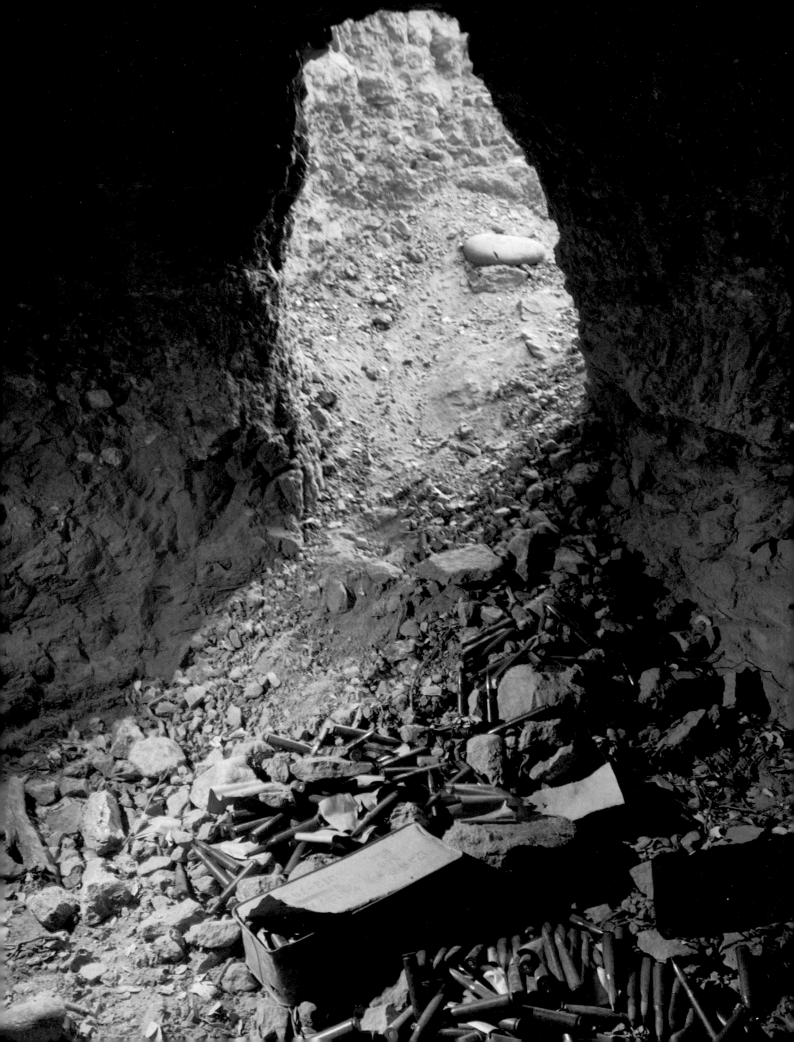

Fugitive

from Afghanistan to Saddam Hussein, the Taliban regrouped, and Osama bin Laden drew a deep breath. Later, in one of his boastful tapes, he would claim that the West's ineffectiveness at Tora Bora was indicative of its lack of spirit and resolve.

Tora Bora: such an interesting and remote place to become central in a story as large as this. It was from Tora Bora that bin Laden had, in 1996, issued his "Declaration of War Against the Americans Occupying the Land of the Two Holy Places"—unable to bring himself to write Saudi Arabia's modern name. "Muslims burn with anger," the declaration read. It urged like-thinkers to "initiate a guerrilla warfare, where the sons of the nation, and not the military forces, take part in it."

This was the thinking that turned him into our Public Enemy Number One: that all westerners—all the people at their desks, at school or commuting on the train—were the enemy and should be killed if opportunity arose. He might have seen some reason in this philosophy, but to most he seemed an indiscriminate murderer. After 9/11, everyone wanted Osama bin Laden brought to justice.

Everyone? Apparently not. It has been reported that sympathetic Afghans and Pakistanis helped him escape from Tora Bora and ushered him across the border into what is called the "tribal regions" of Pakistan. Whither from there? Well, construction of the formidable compound in Abbottabad was begun in 2003 in the shadow of Pakistan's most prominent military academy—that country's West Point. It is now thought that bin Laden first took refuge there as long ago as 2005, and whether he came and went through the years is, as we go to press with this book, not generally known (the very best U.S. intelligence had it at only a 55 percent probability that he was actually in residence on May 2). How could he have been hiding in, as they say, such plain sight? These are questions still being asked. Not least, in Pakistan. Of Pakistanis.

During his years as a fugitive, bin Laden gloried in the taunt, and if he remained prominent as a notorious and at-large killer, he was less and less effective as an operative terrorist. Al-Qaeda was not a player in the populist uprisings that marked the "Arab spring" of 2011. A new brand of activism that was far more democratic and less lethal was in play. Whether this bothered bin Laden, we will never know. He would not live out the spring.

While forensic units were sifting through the mountains of rubble in New York, smaller mountains were unseen in Afghanistan. It would not take long for the U.S. to launch its war there—this war being a hunt for bin Laden. Whether America became unduly distracted by Iraq will be debated forevermore.

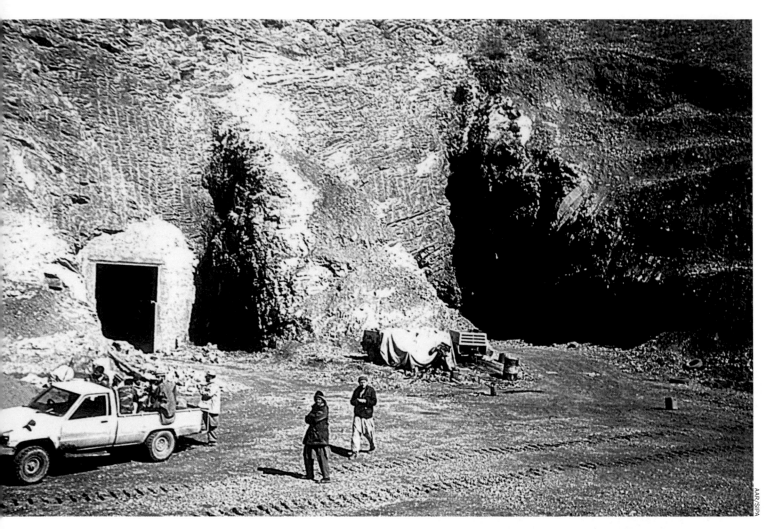

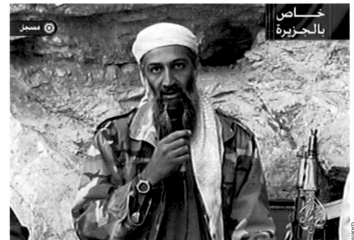

He is quickly on the run. The good news for him is that his operatives have, some time before, been engaged in building well-secured mountain redoubts in northeastern Afghanistan (above)—using bin Laden money and in many cases bin Laden equipment from the family's construction company. He couldn't stay in this region forever, though; that much was quickly clear. But he was probably still there when, on October 7, 2001, a video featuring him and his top lieutenant, the Egyptian jihadist Ayman al-Zawahri (who had replaced Azzam as a muse), was released. In the footage (right), bin Laden praises God for the September 11 attacks and swears that America "will never dream of security [until] the infidel's armies leave the land of Muhammad." He alludes in that quotation to Saudi Arabia specifically and the Middle East generally. His more immediate problem is that U.S. armies and allied forces are already on the move in Afghanistan, and more soon will be. Opposite: Anti-Taliban Northern Alliance fighters ride on a T-62 tank past a dead body on a motorway north of the capital city of Kabul on November 13, 2001. The Taliban flees the city as its opposition moves in, but the radical Islamists are not finished for good (and still aren't in 2011, even in the wake of bin Laden's death). Meantime, the United States has initiated air strikes in the mountainous regions where bin Laden is believed to be hiding, and Operation Enduring Freedom is launched.

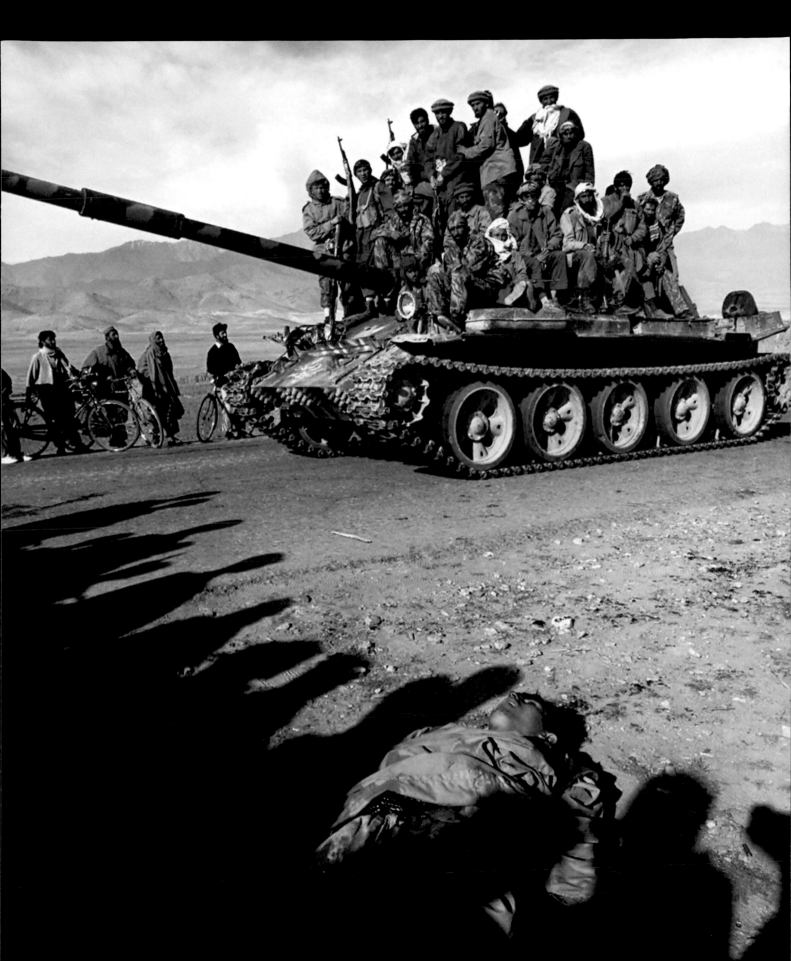

Below: United States Special Operations soldiers keep watch from the open back end of a U.S. Army Special Forces Chinook helicopter near Khoja Bahawuddin, Afghanistan, on November 15, 2001, as they cross by air into Afghanistan from Tajikistan. Two helicopters with small Special Ops teams are providing logistics and security for Andrew Natsios, the administrator of the government humanitarian agency USAID, who is visiting a Northern Alliance stronghold 220 miles northeast of Kabul. At sundown that same day, a U.S. soldier stands guard near a helicopter as Afghan civilians and militiamen loyal to the Northern Alliance look on. Natsios was, at the time, the highest-ranking U.S. official to have visited Afghanistan in 20 years, and his presence signaled that the Americans were coming. They did come, and then many of them left as the war in Iraq intervened.

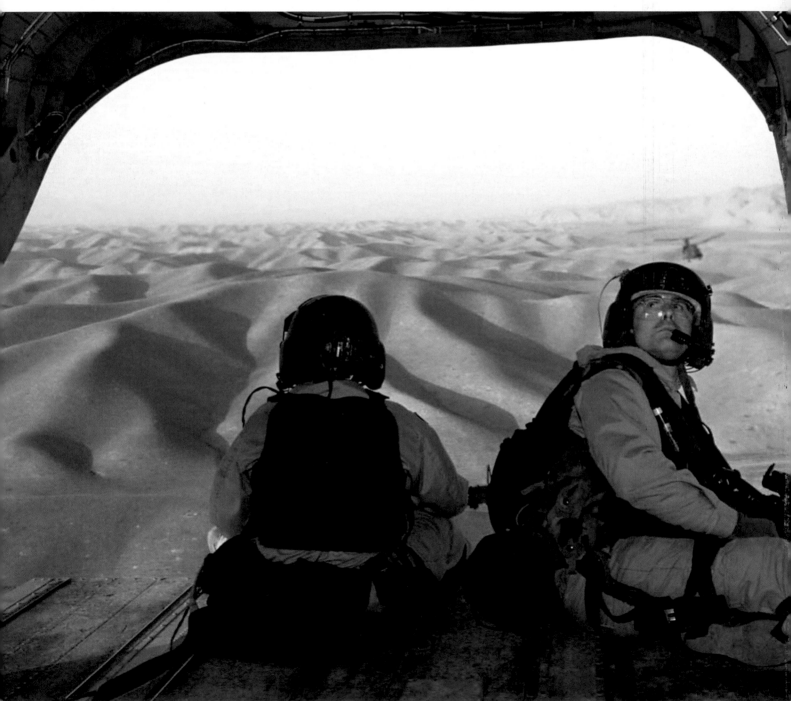

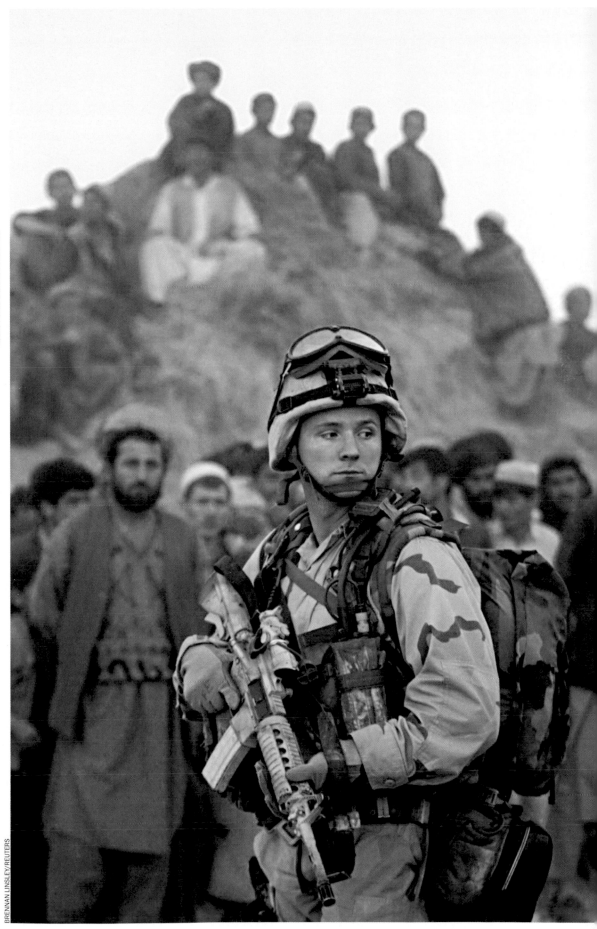

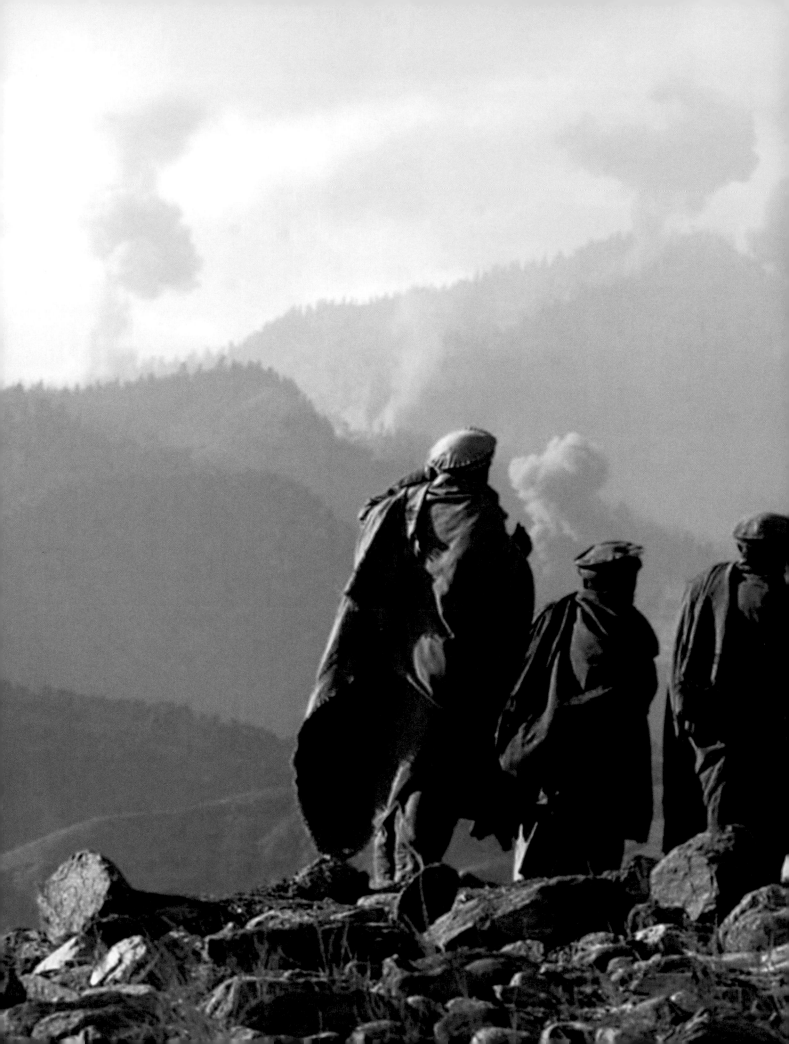

The Battle of Tora Bora has taken on mythic proportions in the saga of Osama bin Laden—entirely because he got away. In this photograph, anti-Taliban Afghan fighters watch several explosions from U.S. bombings in the White Mountains on December 16, 2001. ("Tora Bora" refers specifically to the cave complex within those mountains.) Many al-Qaeda soldiers fought to the death in what they saw as a last stand in northeastern Afghanistan, and their leader eluded the American-led dragnet. Tora Bora is in Nangarhar province, about 30 miles west of the Khyber Pass—the route to Pakistan, which of course was bin Laden's ultimate destination.

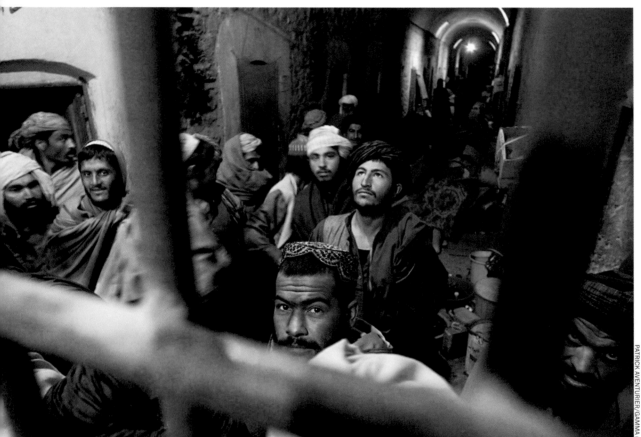

While remote Tora Bora, bin Laden's jumping off point, is central to this story, so is Kandahar, Afghanistan's second largest city, with a population of nearly a half million. It is in the south of the country, also at a high elevation, and has for centuries been a key trading hub as it is on pivotal routes between southern and central Asia. Once the capital of the Afghan Empire, from 1995 to 2001 it was the capital of the Islamic Emirate of Afghanistan—and then 9/11 happened, changing the world everywhere, not least in Kandahar. While American bombers pounded the White Mountains for days on end and the Northern Alliance moved on several fronts, Kandahar was forced to trade its old life for a new one. Above are (left) Taliban prisoners in one of the city's prisons on December 13, 2001, and (right) the spoils of an al-Qaeda training camp near the city that has been raided. The precious blue stones, lapis lazuli, are mined in the region north of the city and at the time of their seizure represented a great potential bounty for the terrorist group. Afghanistan—in major strategic centers—was quickly falling to U.S. forces or allied troops at the end of 2001, but bin Laden was escaping and the Taliban was in no way being eliminated. Today, in 2011, Kandahar deals on a continuous basis with the Taliban insurgency.

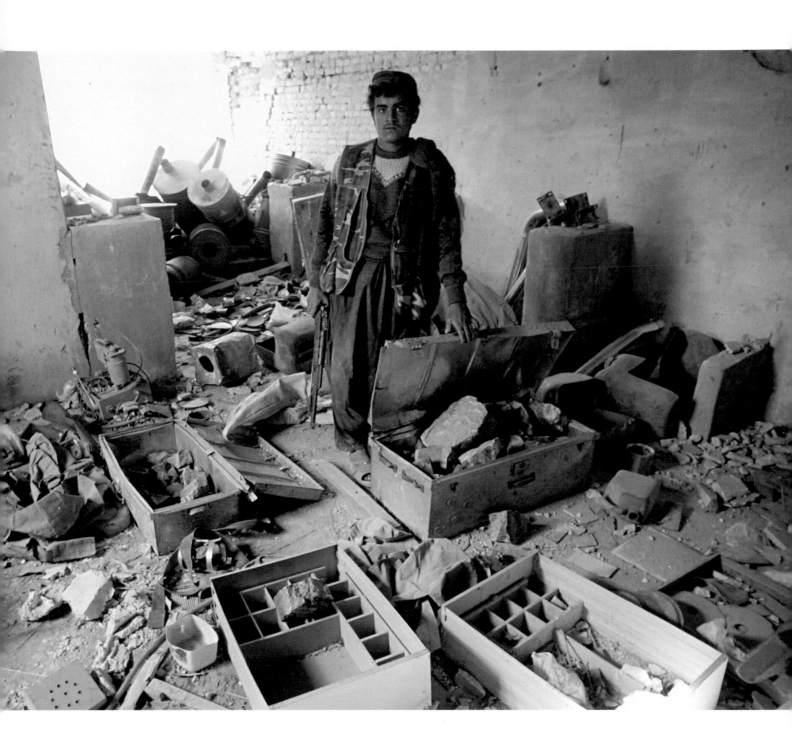

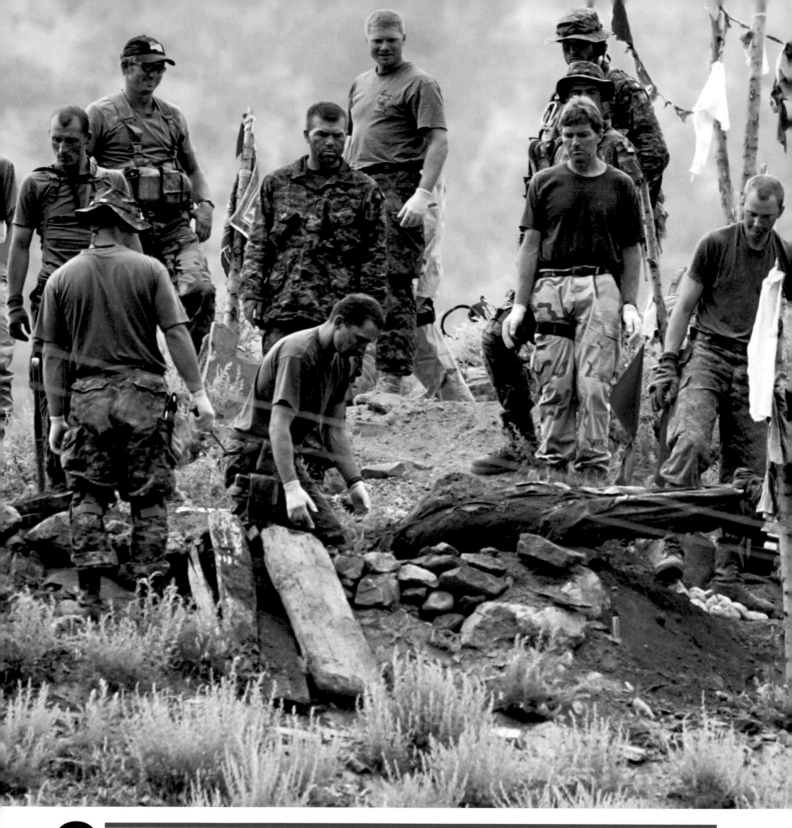

On these next four pages: the aftermath of the Battle of Tora Bora, and in fact the aftermath of the first U.S. effort against bin Laden, al-Qaeda and the Taliban in Afghanistan. Opposite, from top: A dead al-Qaeda soldier at a position overrun by the Eastern Alliance mujahideen at Tora Bora; a notebook recovered from an al-Qaeda cave on December 21, 2001, that gives instructions for bomb-making; and U.S. Army General Tommy Franks, Commander in Chief of Central Command, testifying before the House Armed Services Committee on Capitol Hill on February 27, 2002, about the next fiscal year's defense budget request—a budget that will be largely redirected to Iraq. Above: On May 6, 2002, soldiers from the Princess Patricia's Canadian Light Infantry and U.S. Army personnel pull a body from an al-Qaeda grave site in Tora Bora known by locals as the Al-Qaeda Martyr Memorial. The allied forces knew they had killed a bunch of people, but they didn't know which people.

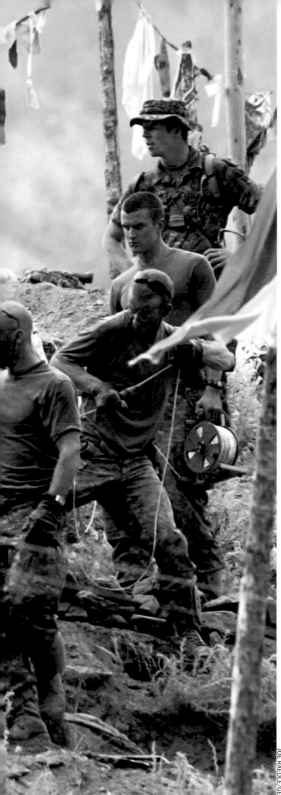

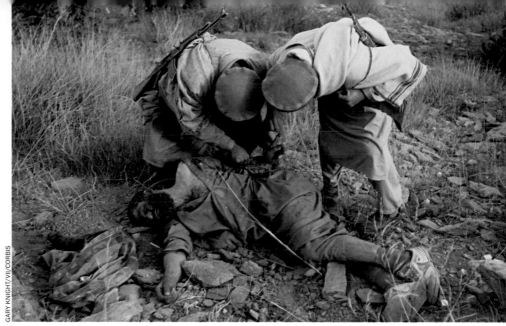

GARY KNIGHT/VII/CORBIS

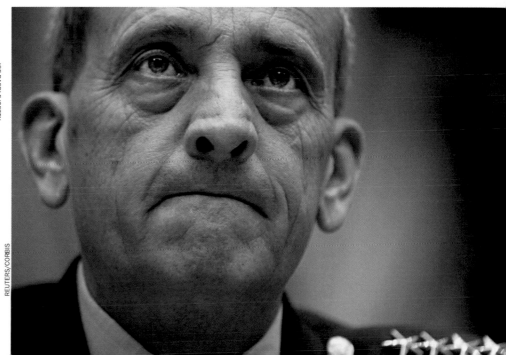

CHRIS HONDROS/GETTY

JOE RAEDLE/GETTY

REUTERS/CORBIS

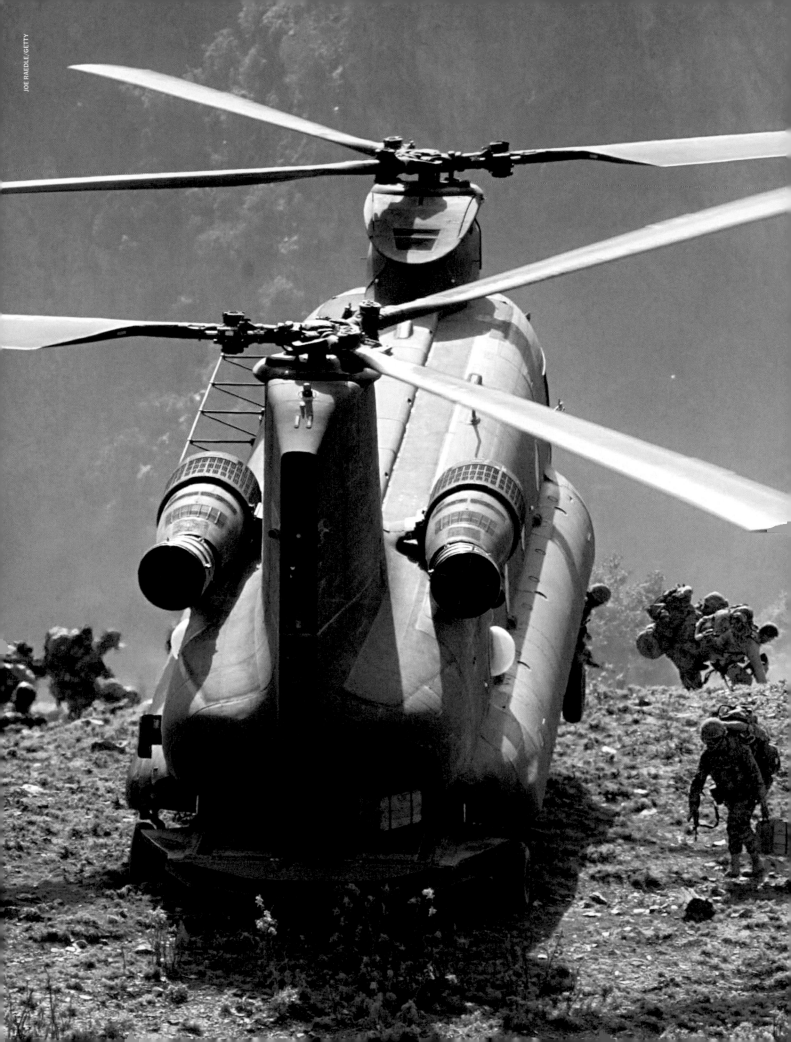

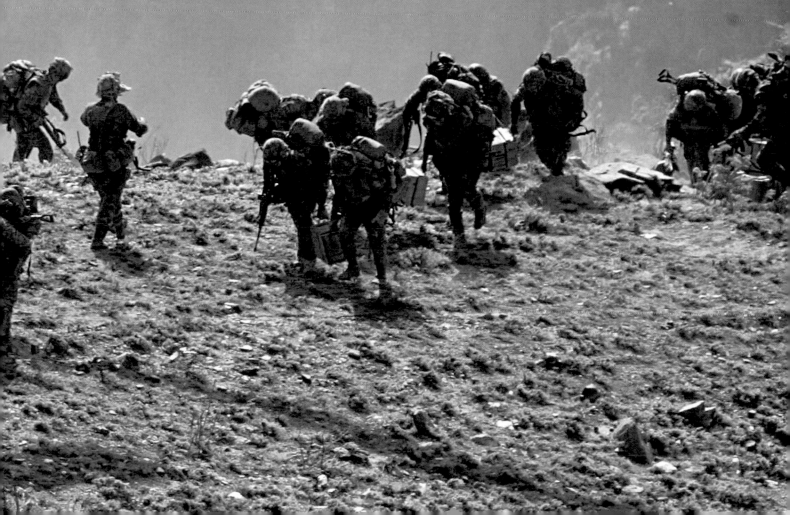

Members of the Princess Patricia's Canadian Light Infantry file into a U.S. Army Chinook helicopter on May 7, 2002, in the Tora Bora valley region after completing the Canadian Operation Torii to destroy underground facilities—caves, tunnels, bunkers—in the mountainous region, hoping to deny al-Qaeda any further use of the warrens that it had built over several years, dating well back into the conflict with the Soviets. As seen on the pages immediately prior, during their four-day mission combing the region, Canadian troops and U.S. forensic experts also dug up bodies—23 of them. It was supposed by this time that bin Laden had gotten away safely, but there was hope against hope that he had been killed in one of the many bombing missions. DNA analysis brought back from Tora Bora only confirmed that he was, in all probability, still on the loose.

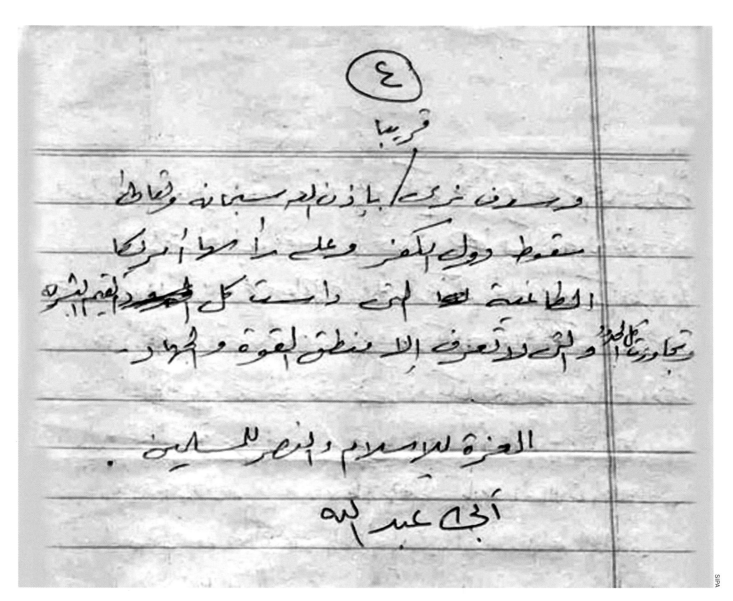

It is now well known that painstaking detective work concentrated on tracing the actual identity and then the movements of bin Laden's most trusted courier led to the discovery of the compound in Abbottabad, but it remains remarkable in hindsight that through the years al-Qaeda's leadership was able to disseminate videos and messages—vital sustenance to the organization's far-flung army—and not be tracked. At one point, an Islamic Web site's correspondent in Pakistan received a copy of a note (above) said to be written by bin Laden: "I send this message to you . . . I am your brother in religion and belief, Osama bin Muhammad bin Awad bin Laden." The handwritten message called on the Afghani people to engage in jihad and resist the American forces in Afghanistan: "I can tell from my place that these great venerations drawn around the super powers do not equal a mosquito wing . . . it is not worth anything in comparison with the power of God." Right: Bin Laden and al-Zawahri confer in their undisclosed location—their "place"—and let their acolytes see it via video. Opposite: Bin Laden walks in the hills as if a free man, but even those who support him know that he is being intensely hunted.

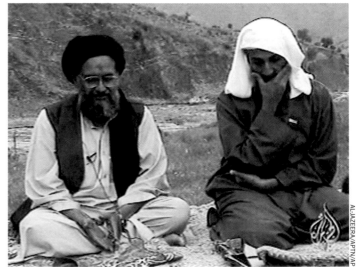

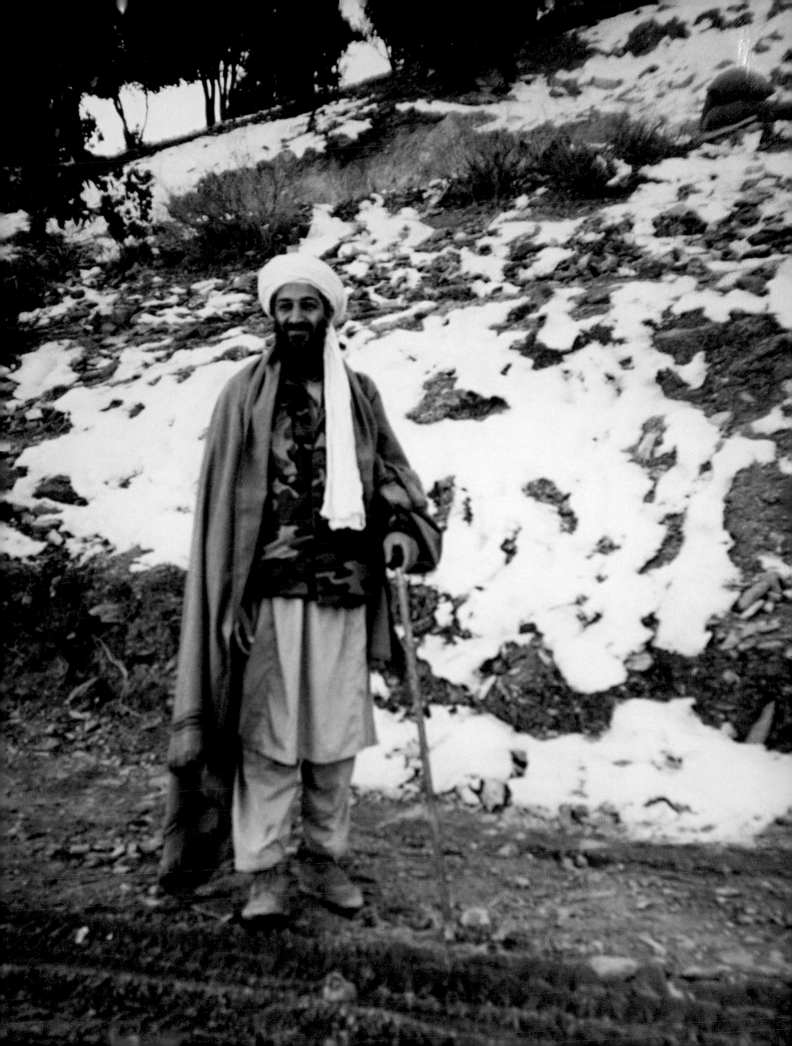

Below: We are now in 2010—March 2 to be precise—and we are in Pakistan. Soldiers inspect a cave that the Pakistani Army said was built and used by the Taliban in Damadola, which is located in what is called the Bajaur Agency in the country's Federally Administered Tribal Areas along the Afghan border. Pakistan, supposedly, has driven out al-Qaeda and the Taliban from one of their principal strongholds in the region, and Pakistan's military now takes reporters and photographers to the place where Ayman al-Zawahri has been thought to be hiding. But al-Zawahri is still at large, and so is Osama bin Laden, who is, as it turns out later, holed up in a large enclave that was certainly built for him in Abbottabad. He is still making videos (opposite, bottom), and is still plotting—perhaps to attack a rail system in the U.S. on the 10th anniversary of his 9/11 attacks. These two fugitives—al-Zawahri and bin Laden—are *still* out there in the spring of 2010. But by the summer, one of them will have been sensed, and the final chapter will begin to be written for Osama bin Laden.

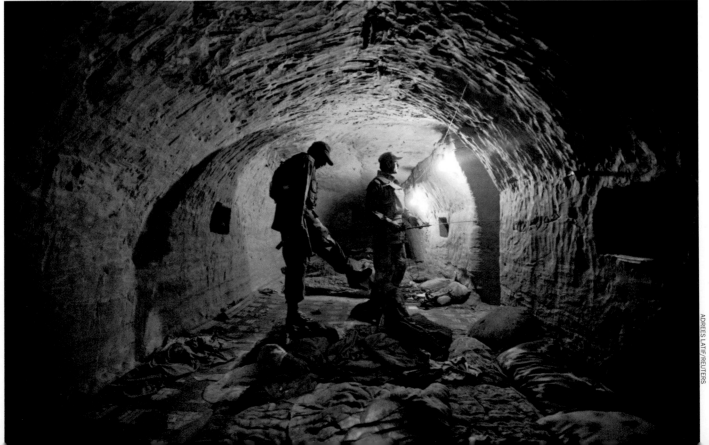

ADREES LATIF/REUTERS

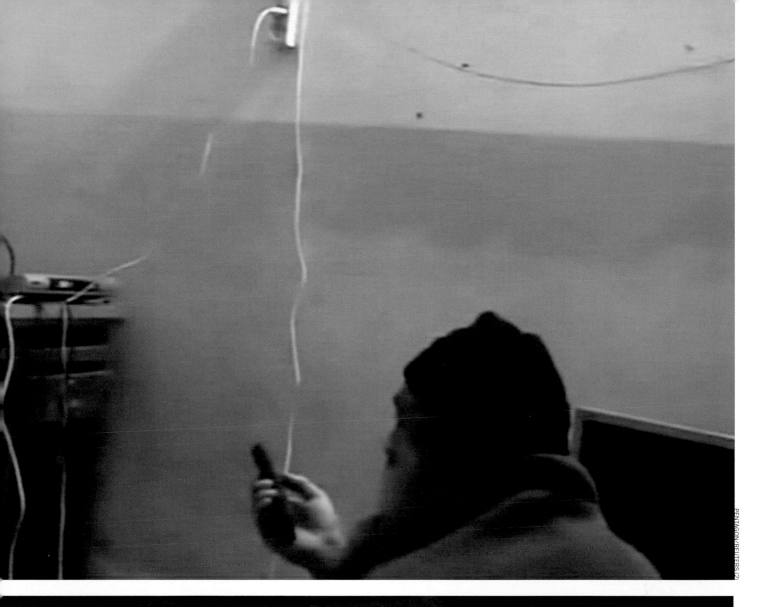
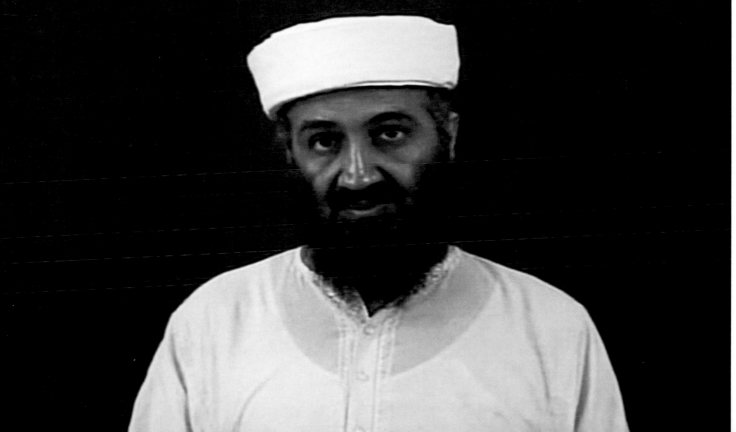

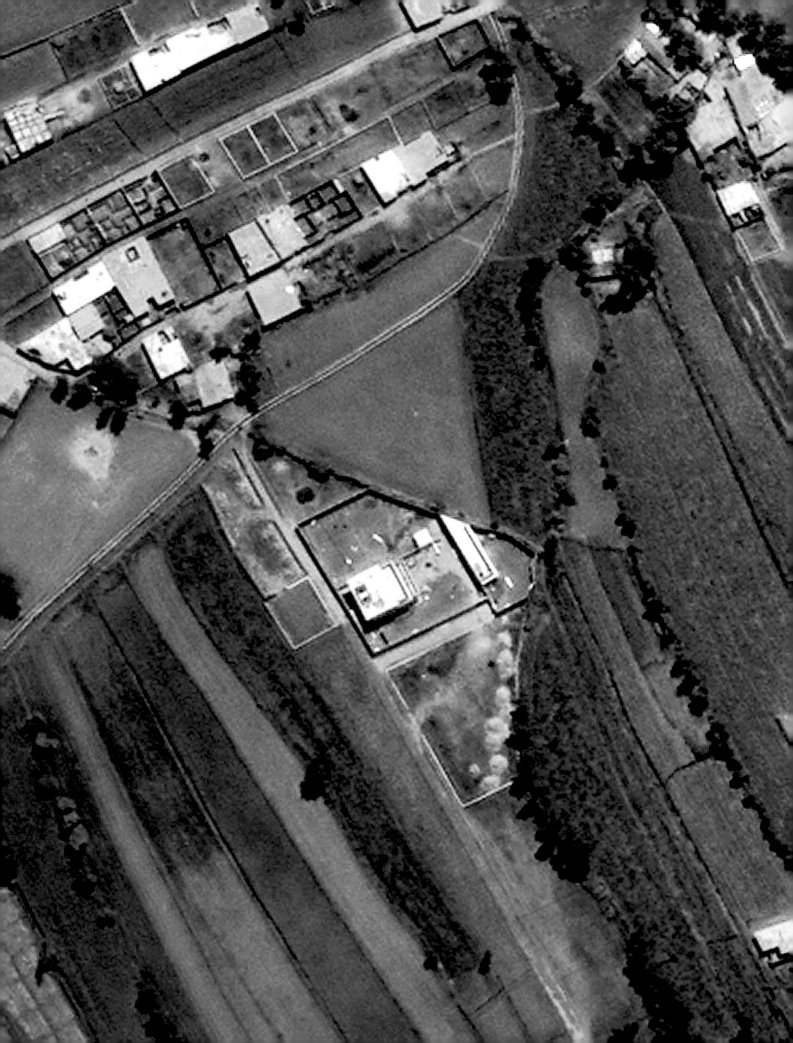

Few saw this coming, and certainly no one in al-Qaeda did. It was an extremely well kept secret within the U.S. intelligence and military community—and even the term "community" falsely implies an enlargement of the actual number of people involved. There weren't many at all beyond the combatants who were practicing for the raid and the handful who needed to know in Washington. Barack Obama didn't tell his wife, never mind any authorities in Pakistan who might spill information that could find its way up the road from Islamabad to Abbottabad.

Abbottabad. What was that? Where was that?

It was and is a very nice, medium-size city of some affluence, grace and culture in the north of the country. It is, figuratively speaking, a stone's throw from the capital (to the south) and the Afghanistan border (to the west). Its nickname is "the city of schools," and it can be thought of as a Pakistani equivalent of Cambridge (either Massachusetts or England). Its population is among the nation's youngest and smartest. It is also where the esteemed Pakistan Military Academy is located. The academy has three training battalions in constant residence.

The compound that was built for Osama bin Laden beginning in 2003 (he probably moved in two years later) is about a thousand yards from the academy, and surely did not rise unnoticed. This new *thing*, with walls up to 18 feet high and topped with razor wire, could have been hiding spies from India, for goodness' sake. There is absolutely no way the authorities in Pakistan would not have investigated. Somebody knew, and somebody helped. But that is an ongoing question as our book heads for press, a question to be resolved in a future day with consequences yet unknown.

What we do know: Bin Laden did escape from Tora Bora in 2001 and was sequestered in the tribal regions of Pakistan. The Abbottabad compound was built, and apparently the many people who eventually entered it didn't leave—or at least not regularly. They would answer the door when local children kicked a ball over one of the high walls, but they didn't attend block parties on either Kakul or Murree Road. On the one-acre million-dollar property there was a long driveway with high walls designed to fence in intruders—a "kill zone"—and an outbuilding where bin Laden's most loyal defender, the courier Abu Ahmed al-Kuwaiti, lived and died. The word *compound* has been often applied

This satellite image was taken on June 15, 2005—in other words, right about the time that Osama bin Laden, three of his wives, and other relations and associates moved into their large compound in Abbottabad, Pakistan. This place would be bin Laden's refuge for several years, until May 2, 2011, when he was killed there.

REUTERS

by us and others, and it is accurate: This was not a home or a house or an estate. It was a military encampment, built for defensive purposes.

Abu Ahmed al-Kuwaiti, the courier, was in fact a native of Kuwait. So is Khalid Shaikh Mohammed, al-Qaeda's former propaganda minister and a chief planner of the 9/11 attacks, who was captured by Pakistani security forces in 2003 and is still today held at the U.S. facility in Guantánamo Bay, Cuba. Among other techniques used in questioning Mohammed was waterboarding, and whether this amounted to torture became an issue again in the wake of 5/2 when it was learned that the interrogations of Mohammed (many of which did not include waterboarding, but may have involved other "enhanced" techniques) spurred the CIA's interest in looking more closely at al-Kuwaiti. The reaction to the killing of bin Laden was very complicated. People who abhorred torture, disapproved of a mission that was probably more "kill" than "capture" and might have been against the taking of any human life in any circumstance were nonetheless relieved to wake up on May 2 to the news that the terrorist was gone from the face of the earth.

The President, who was first informed in August 2010 that we might have located bin Laden, eventually decided against a massive air strike in favor of a commando raid that would prove conclusively that the target had been eliminated (and, not incidentally, might come away with useful evidence of future terrorist plots). But he was worried. No one was dead certain that bin Laden was in there, and several raids in the past had gone badly; surely, the phrase *Black Hawk Down* was in everyone's mind. "I don't want you to plan for an option that doesn't allow you to fight your way out," Obama told his military executives, referencing not only al-Qaeda opposition but the possibility that the Pakistani military might get involved. An operation involving 79 commandos in four helicopters was rehearsed—over and over again—that would allow all of the Americans to get in and out in a half hour. In the event, they needed an extra 10 minutes.

The helicopters buzzed in under cover of darkness. One malfunctioned and was forced to "hard land"; it would be useless during getaway. In Washington, the President and his associates in the White House situation room, monitoring events in real time, were tense—some were fearful—but composed. People were killed in the compound as the Seals moved about. Bin Laden was found on the third floor and was shot in the head and chest; his body was taken to the helicopter and later that morning was buried in the Arabian Sea.

BRENDAN SMIALOWSKI/SIPA

Late on Sunday, May 1, politicians and journalists in Washington got word that something big was about to be announced. But what? Gadhafi? Syria? The President told them— eloquently, calmly, with context, with graciousness expressed for work started by the previous administration and without any braggadocio—that Osama bin Laden had been killed. And then he left the East Room.

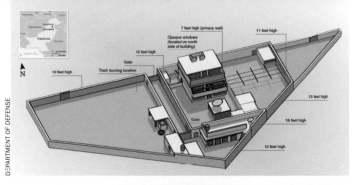

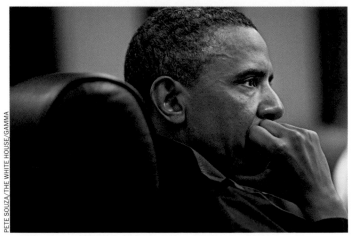

The CIA and Department of Defense obviously had spent many, many hours learning everything they could about the compound (left, a DOD diagram; bin Laden was found on the third floor of the large building), and the two dozen Navy Seals who would take part in the raid, riding in on two helicopters, had spent an equivalent time practicing at a replica layout. None of this preparation made the early morning hours of May 2 (still the afternoon of May 1 in the United States) any less tense for the participants, who included in Washington as principal players the President (left) and CIA director Leon Panetta (below, in blue shirt and blazer, addressing his Commander in Chief as Secretary of Defense Robert Gates, right, listens). In Pakistan, other Americans simultaneously at work set off explosives, destroyed walls and a false door and fired rounds (opposite, top, in an image from video footage taken on a mobile phone). When the dust had cleared and the world started to focus on the compound, the astonishment that bin Laden had been living in a place so mundane and out in the open, despite its many high walls and razor-wire protections, began to set in. Opposite, bottom: Curious neighbors and TV news crews are kept at bay by Pakistani police after the Americans have cleared out.

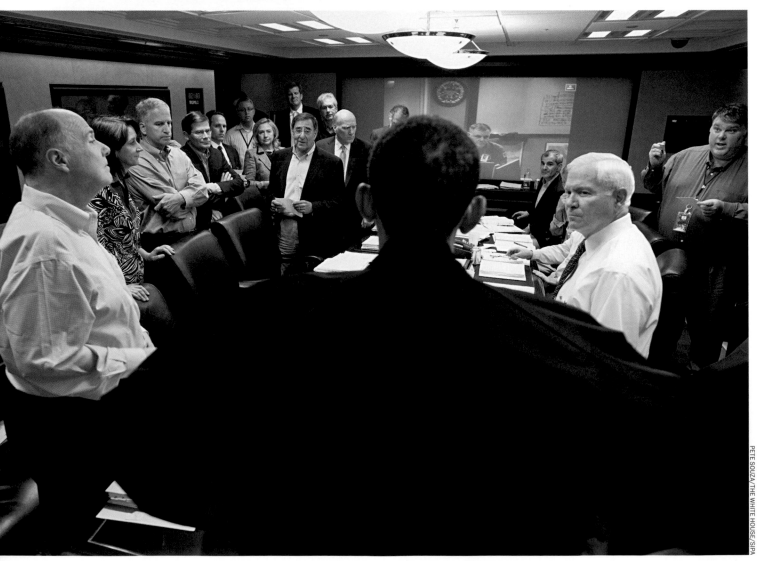

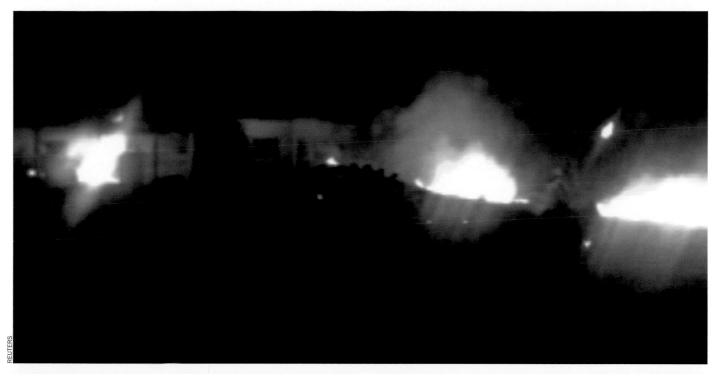

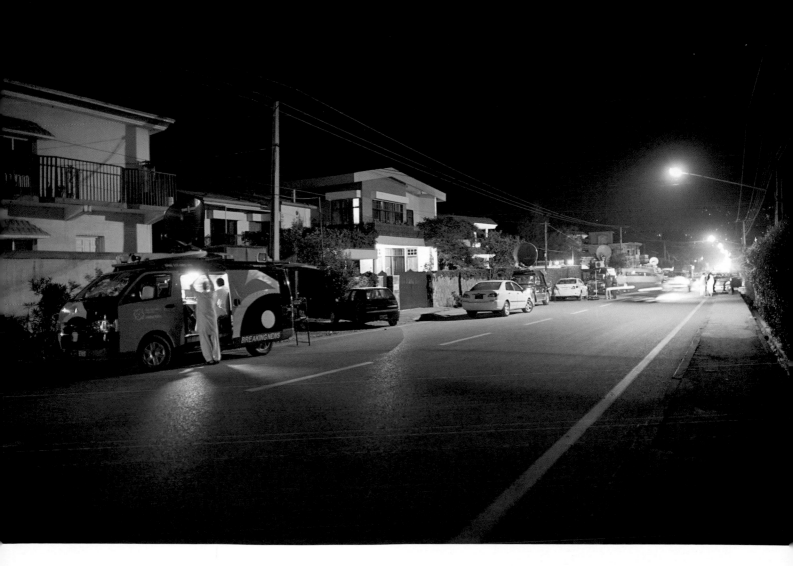

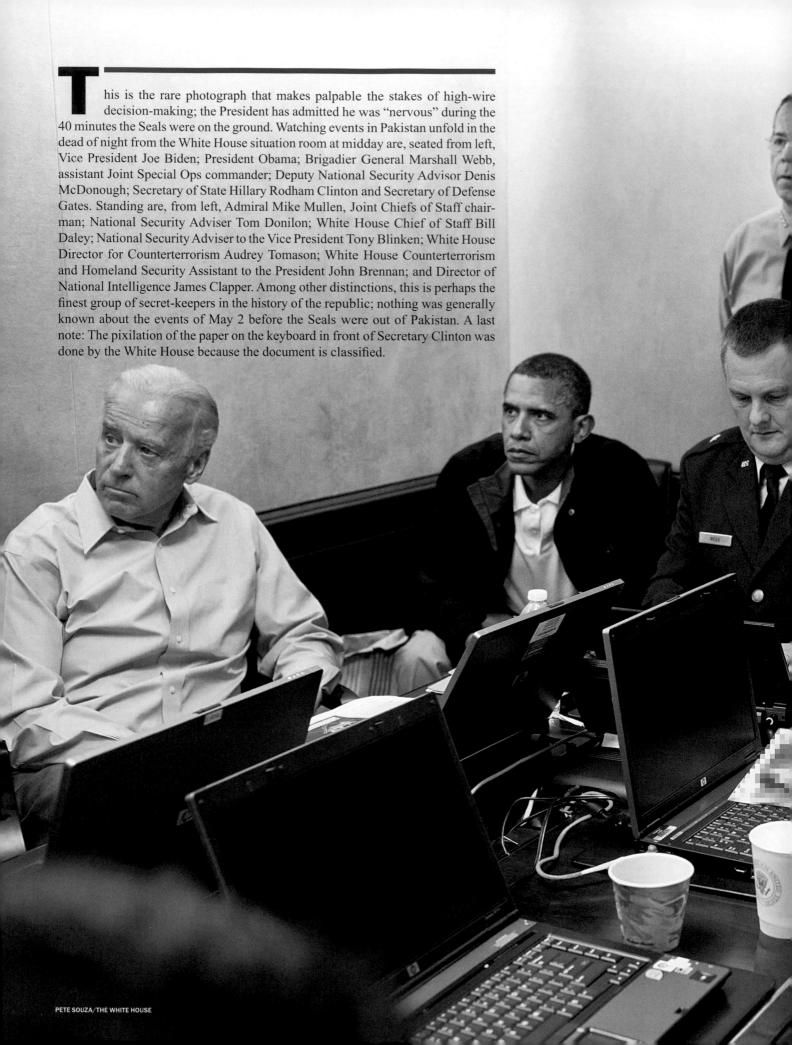

This is the rare photograph that makes palpable the stakes of high-wire decision-making; the President has admitted he was "nervous" during the 40 minutes the Seals were on the ground. Watching events in Pakistan unfold in the dead of night from the White House situation room at midday are, seated from left, Vice President Joe Biden; President Obama; Brigadier General Marshall Webb, assistant Joint Special Ops commander; Deputy National Security Advisor Denis McDonough; Secretary of State Hillary Rodham Clinton and Secretary of Defense Gates. Standing are, from left, Admiral Mike Mullen, Joint Chiefs of Staff chairman; National Security Adviser Tom Donilon; White House Chief of Staff Bill Daley; National Security Adviser to the Vice President Tony Blinken; White House Director for Counterterrorism Audrey Tomason; White House Counterterrorism and Homeland Security Assistant to the President John Brennan; and Director of National Intelligence James Clapper. Among other distinctions, this is perhaps the finest group of secret-keepers in the history of the republic; nothing was generally known about the events of May 2 before the Seals were out of Pakistan. A last note: The pixilation of the paper on the keyboard in front of Secretary Clinton was done by the White House because the document is classified.

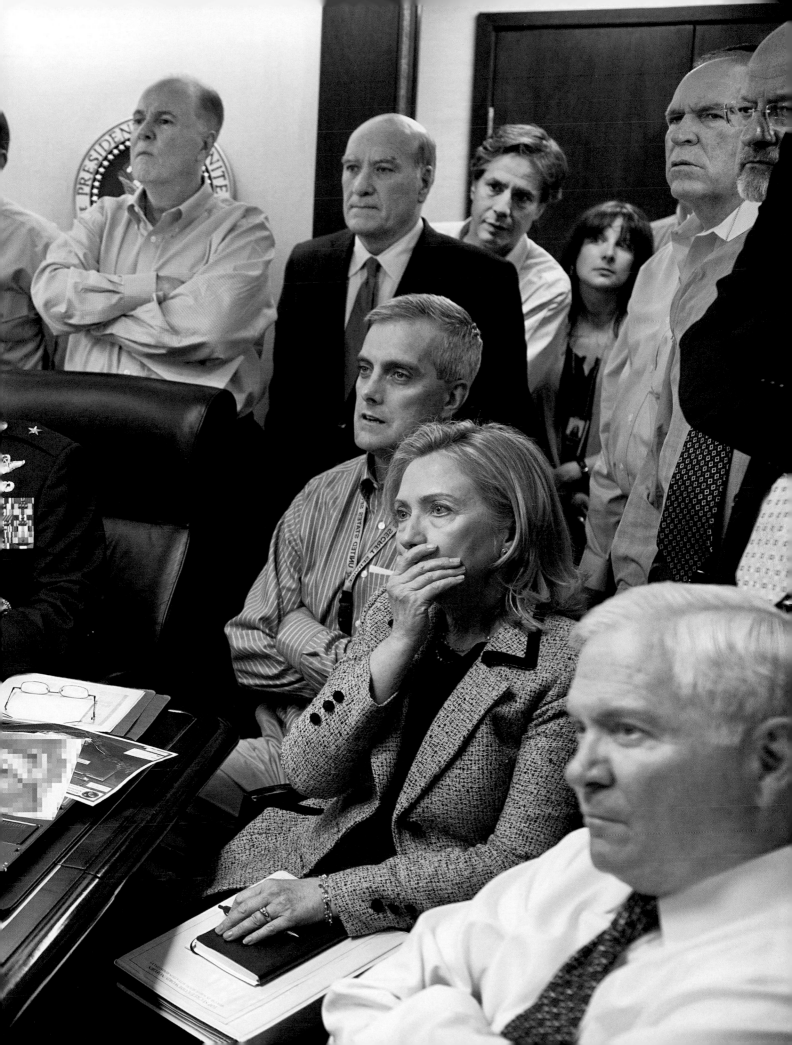

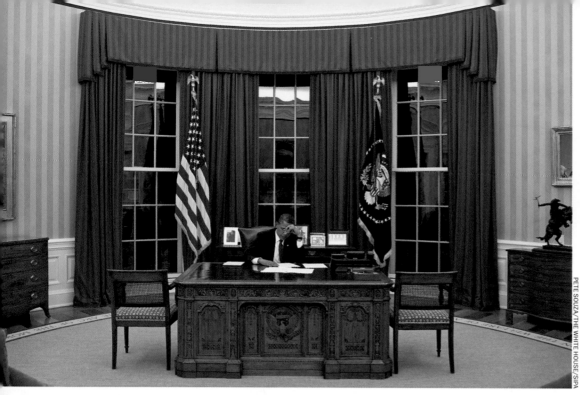

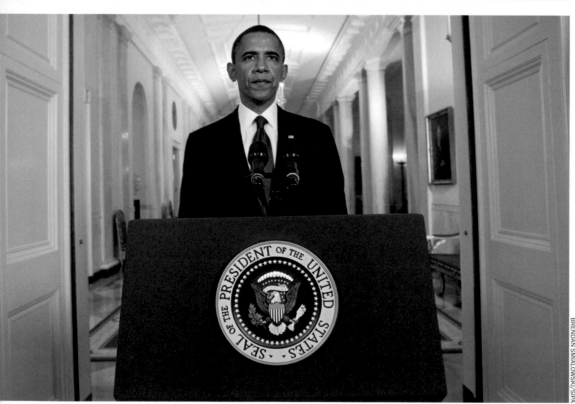

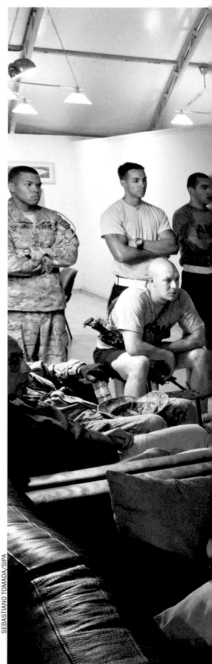

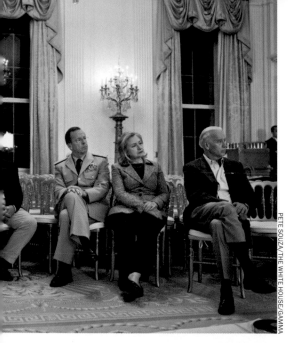

PETE SOUZA/THE WHITE HOUSE/GAMMA

At this point, Obama has said, he was "relieved"—relieved at the outcome, and especially that his American forces have been safely returned from their mission with no casualties. On the opposite page, from top, the President edits his remarks in the Oval Office prior to making a televised statement detailing the dramatic events that have transpired in a place as yet unknown to most Americans, a place called Abbottabad, and he then delivers those remarks. Left: Senior administration officials listen to his statement in the East Room (from left, Clapper, Donilon, Panetta, Mullen, Clinton and Biden). Below: At the USO building in Kandahar Airfield in Afghanistan, U.S. soldiers also watch as President Obama announces the death of Osama bin Laden. It was noted by many in the immediate aftermath that the taking of bin Laden's life might have made more precarious—more dangerous—the lives of American service members and civilians, both, in the short term. But all were content that he was gone. The President said that any of his countrymen who didn't think bin Laden, the murderer of so many innocent civilians, richly deserved his fate should "have their heads examined."

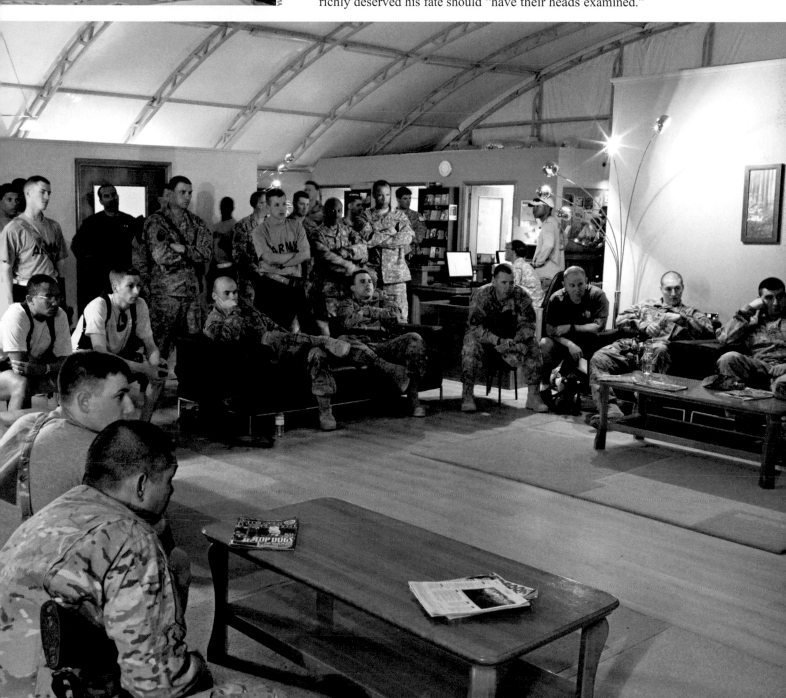

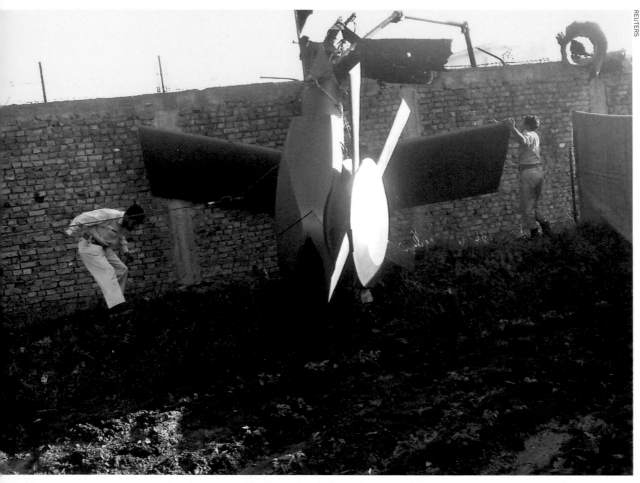

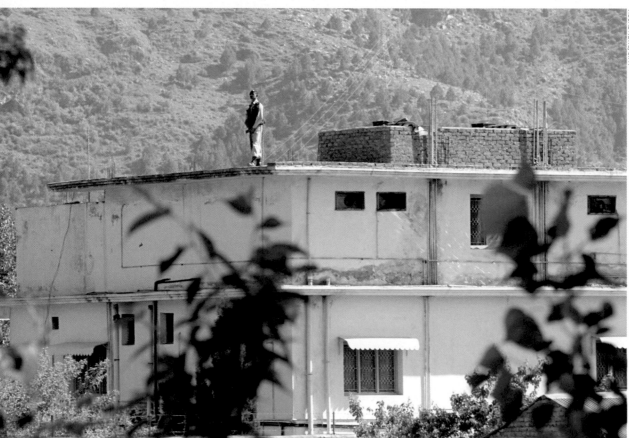

Everyone, everywhere was stunned by the news, and as the sun came up in Abbottabad on May 2, a bewildered Pakistani police and military moved in to secure the site, collect what had been left behind and start taking depositions from the survivors. Among the people and things they found were the three wives who had been in residence (the youngest of whom was injured), the dead son and the many remnants of a massive, fast-moving raid. They of course did not find bin Laden's body, nor the vast store of paperwork, computer discs and hard drives that the Americans had scooped up in an effort to forward their country's War on Terror. Opposite, top: Part of the helicopter that had been forced to hard land on the way in, and that was partially destroyed by departing Seals on their way out. Bottom: A Pakistani officer on duty at the compound, standing on the roof above the third floor, where bin Laden was killed. Below: On May 5, Pakistani seminary students approach to visit the final hiding place of Osama bin Laden. The previous day, seminarians had rallied in Quetta and shouted anti-American slogans. Many in Pakistan (including, of course, the country's leadership, which hadn't been tipped to the raid) were either upset by or angry with what had transpired.

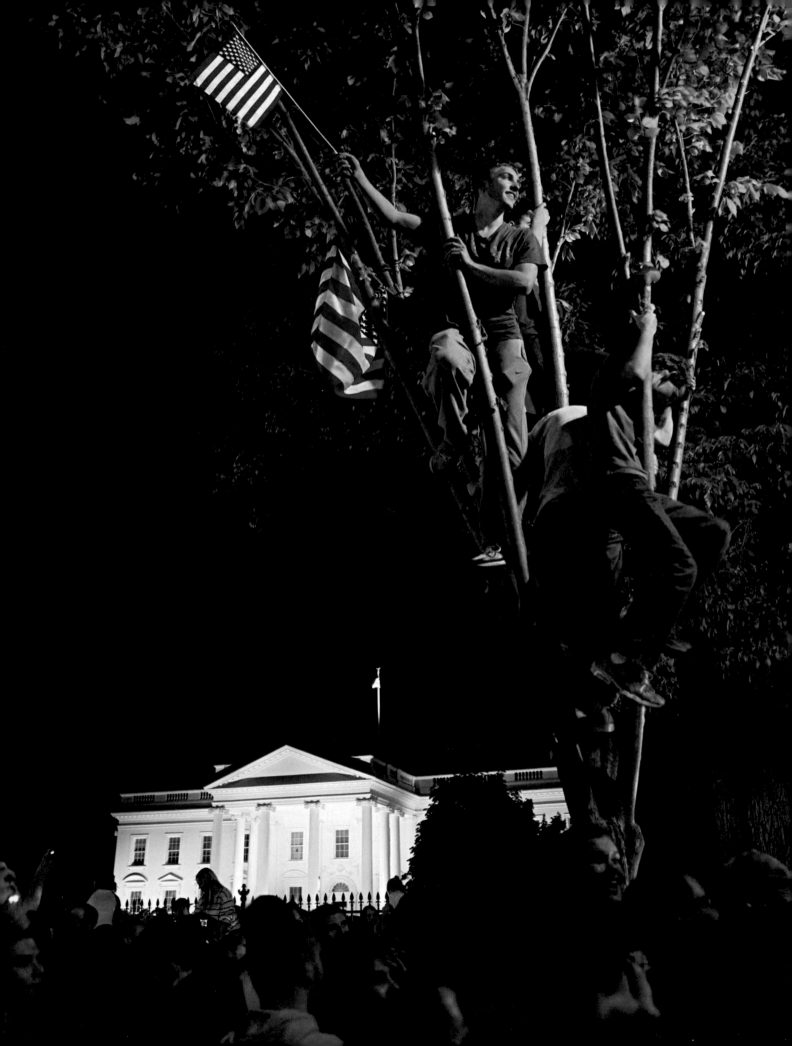

How one reacted was entirely dependent on who and where you were. The Sunday night baseball game of the week was between the Philadelphia Phillies and New York Mets, and fans in the stands started getting text messages from friends about what had been announced. A strange murmur rose in the ballpark, and then a chant swelled: "USA, USA!" Hundreds of people made their way to Ground Zero in Manhattan, and thousands gathered in front of the White House to cheer and celebrate (opposite). Newspaper readers worldwide tried to digest the mystifying story, including on May 3 those seen at right in Riyadh, Saudi Arabia, where bin Laden had once been a feckless youth, then a national hero and finally, at least to the powers that be, a political pariah. Below: The following day, in Peshawar in Pakistan's tribal areas, where bin Laden will always be revered by many, 100 lawyers gather in a symbolic funeral prayer. The White House decided to not release the graphic photography of bin Laden dead, which seemed a wise decision and respectful of these many different people, all around the world.

MOHAMMED MASHHOR/STR NEW/REUTERS

FAYAZ AZIZ/REUTERS

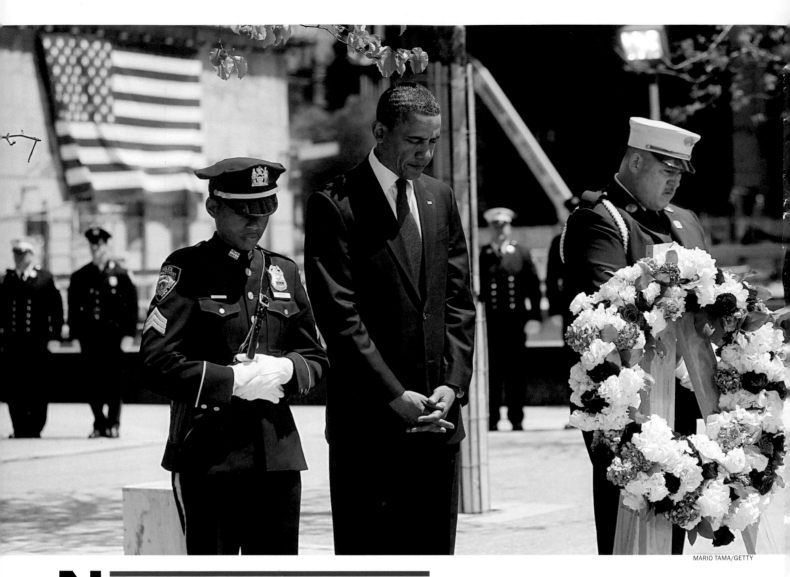

Nearly 10 years earlier, President George W. Bush had gone to Ground Zero and had said, through a bullhorn, "The people who knocked these buildings down will hear all of us soon." Those people—and most important, that person, Osama bin Laden—now had. President Barack Obama visited Ground Zero for the first time since taking office and said, "When we say we will never forget, we mean what we say." He visited a firehouse that day, accompanied by former New York City mayor Rudolph Giuliani, and shared hugs, sports talk and a lunch of eggplant parmesan and mesclun salad. He met several young people who had lost parents—and the chance to ever get to know them. He laid a wreath in front of the so-called Survivor Tree, which had been damaged but not destroyed by the awful carnage of 9/11. On this sunny Thursday in May 2011—a day not unlike that September Tuesday in 2001—appropriate warnings had been issued by all the appropriate government agencies: The War on Terror is not over, we must remain vigilant, there could be reprisal actions. But the great villain, the specter who had loomed in the American consciousness like no one since Hitler, had been eliminated. The President's day in New York City was in no way celebratory but, rather, solemn. Emotional to be sure, but overarchingly solemn. Appropriately solemn. The large unsaid seemed to be: None of this should have happened.

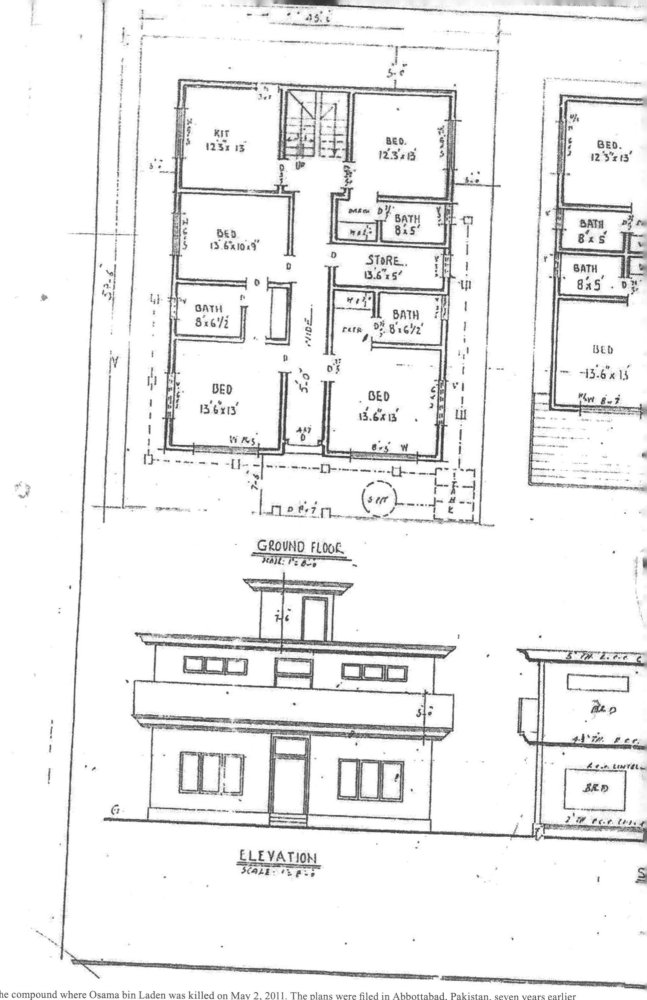

GROUND FLOOR

ELEVATION

The architectural plans for the compound where Osama bin Laden was killed on May 2, 2011. The plans were filed in Abbottabad, Pakistan, seven years earlier by the property's titular owner, who was bin Laden's courier. Obtained in Abbottabad by Andrew Buncombe, journalist for London's *The Independent*.